D0546915

IMAGES
of America

FORGOTTEN
ALBUQUERQUE

ON THE COVER: Native American silversmiths Helen Lowley Emerson and Mike Lowley pose for a publicity photograph at Albuquerque's old Municipal Airport terminal in the late 1940s. Albuquerque's promotion of itself has often walked a line between celebrating the Southwestern cultures that lay at its heart and commoditizing them. (Courtesy Albuquerque Museum, Barnes and Caplin, PA 1982 180.26.)

IMAGES
of America

FORGOTTEN
ALBUQUERQUE

Ty Bannerman

ARCADIA
PUBLISHING

Published by Arcadia Publishing
Charleston, South Carolina

Printed in the United States of America

Library of Congress Catalog Card Number: 2008928807

For all general information contact Arcadia Publishing at:
Telephone 843-853-2070
Fax 843-853-0044
E-mail sales@arcadiapublishing.com
For customer service and orders:
Toll-Free 1-888-313-2665

Visit us on the Internet at www.arcadiapublishing.com

To my wife and my son, and our discoveries together

CONTENTS

ACKNOWLEDGMENTS

This book was made possible through the tireless, and so often uncelebrated, work of Albuquerque's historical preservationists. From the staff at the University of New Mexico's Center for Southwest Research, to Glenn and Sandra Fye at the Museum of Albuquerque, to Joe Sabatini at the Albuquerque Public Library, these people and the institutions behind them proved invaluable to my explorations into Albuquerque's past.

Nancy Tucker, head of the New Mexico Postcard Club, deserves special mention. She has been extremely giving with both her collection and her time, and has shown incredible patience as I invaded her home day after day.

And, of course, my family is deserving of so much more than a mere "thank-you" can express. As this book's deadline grew ever closer, and as health issues threatened to delay it indefinitely, it is safe to say that without their support, *Forgotten Albuquerque* would never have come to be.

INTRODUCTION

Albuquerque is a city, like all cities, of contradiction. Even at its beginning in 1706 (that is, the first time the name "Alburquerque" was applied to any settlement between the Rio Grande and the Sandia Mountains), the contradictions stood starkly against each other. Gov. Cuervo y Valdez, in his report to his Spanish superiors, was proud to have created a new villa so soon after the reconquest of New Mexico and touted its size and early achievements in forming a defendable and functional town center:

> I certify to the king, our lord, and to the most excellent senor viceroy . . . that I have founded a villa on the banks and in the valley of the Rio del Norte in a good place as regards land, water, pasture and fire wood. . . . I gave it as patron titular saint and glorious Apostle of the Indies, Senior Francisco Xavier, and called and named it the Villa de Alburquerque. . . . Thirty-five families have been settled including two hundred and fifty persons, large and small. The church is done; it is very spacious and decent. Part of the minister's dwelling is also finished. The principal royal houses are begun. . . . The fields are sown; everything is in good order and there has been no expense to the royal treasury.

But the governor, hungry for good news to report to Spain soon after his interim appointment, had exaggerated. At its "founding," La Villa de Alburquerque lacked the church Cuervo lauded, the "royal buildings" had not been begun, and the 35 families that Cuervo claimed had settled the area were in actuality more along the lines of a paltry 12. Instead of the tightly centralized villa Cuervo described in accordance with Spanish law, there was a collection of spread-out farmhouses nestled in the forest along the Rio Grande, most of them occupied for decades previous to his announcement. Cuervo's grand description was belied by the loose community's unassuming actuality, and it would not be until years after its founding that La Villa de Alburquerque would begin to reflect its sponsor's vision.

So it has always been. Albuquerque has been guided by the vision and rhetoric of its leaders but has been defined by the lives and needs of its citizens, and there has often been a marked divide between them. The historical "three peoples" of the Rio Grande Valley—Spanish, Puebloan, and Anglo—are also contradictions; there are stark cultural differences, economic divides, and shifts in values and beliefs between them. The 20th century has introduced new groups to the mix: Albuquerque now has a thriving Vietnamese community, neighborhoods of Russian émigrés, and more recent Mexican immigrants, to name but a few of the more prominent examples. How can you assess the identity of a city when it clearly has not one but many and when each can seem so dramatically different from the others?

The answer lies somewhere between the contradictions—that is where you can find the heart of the city, the truth of it. A city's identity is the sum of its many identities and more besides, for identities blend one with the other and thus change each into something unique, something new: Spanish Catholicism in the heart of the ancient pre-Spanish Pueblos; the Matachines dancing

in the Spanish villages, a blend of European, Moorish, and Native American traditions; the Pueblo Revival buildings designed by Anglo architects to reflect, celebrate, and commemorate the traditional adobe forms and structures of the old Southwest. That is Albuquerque.

To understand the city, you must know its history and the cities it has been. During the past three centuries, Albuquerque's identity has shifted and changed as the contradictions that form it have shifted and changed—from the loosely affiliated villa of farmhouses along the river; to the newly won American territorial town, bustling with invading Easterners and their money-making ventures; to the "Heart of the Health Country," the last desperate hope for thousands diagnosed with a deadly disease; to the neon river of the legendary U.S. Route 66, bringing a new variety of motoring tourist to see the city. And now, in a new millennium, in a new Albuquerque, all of that is still here, rustling beneath the surface like leaves on a forest floor. If you know what to look for, you can see them; those lost Albuquerques haunting us like ghosts.

This book cannot hope to capture the totality of the city's history. Even a full library of volumes could not do that, much less the 128 pages presented here. This book is an introduction to Albuquerque's past selves: a skipped stone across history, with each chapter a brief landing and ripple. My hope is that even with a casual glance, a riffle through the pages, a brief moment contemplating the previous lives of this Southwestern city, you will find yourself wanting to know more, to discover forgotten Albuquerque for yourself.

One

BEFORE THE VILLA

When does a city begin? If we move beyond the vagaries of documentation and changes in names and cultures, if we expand our definition of "beginning" to include when people first began living in the area now known as Albuquerque, the answer is somewhat disarming. Western cities are supposed to be recent developments, new additions to the American landscape, lacking in the saturated history of a New York or a Philadelphia. And yet, with an open eye, we realize that the Rio Grande Valley has been occupied, more or less continuously, for approximately 10,000 years.

Ten thousand years—how strange and far away that seems. Certainly, the people who first came into the valley lived very different lives than us. Although much about them is uncertain, we know they were hunters, pursuing herds of bison and other grazing animals along the waterways, briefly settling into camps for the seasons and then moving on. Their lives and beliefs, traditions, and worldview are almost entirely unknown to us, and looking back, it can feel as though we are entirely removed from them and their world. But even here in our ever-expanding asphalt-covered metropolis, we can feel and understand something of their lives simply by looking east. There stand the eternal Sandia Mountains, rising starkly out of the plains, their craggy face little changed over the millennia separating those long-ago people from us.

Later, as the seasons grew warmer and drier, the great grassy plains of the valley retreated to the north and east. The hunters of the Clovis and Folsom cultures may have followed the herds, making way for an agricultural-based people to enter the valley in their stead, or perhaps they themselves stayed and adapted to a farming lifestyle. Regardless, the history of the next half-dozen millennia is that of a people who became increasingly sedentary, building permanent dwellings that became loose villages and then tightly centralized and multistory pueblos.

When the first Europeans arrived in the Rio Grande Valley in 1540, they found a thriving culture of villages along the river. They called it the Province of Tiguex.

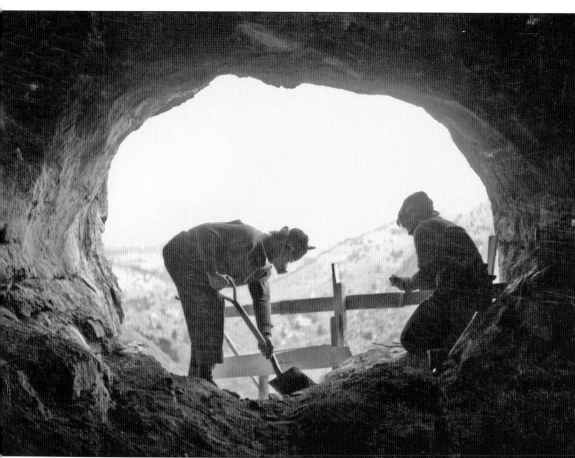

The study of the past has sometimes been a woefully inexact science. In 1931, Frank Hibben, a student at the University of New Mexico, discovered stone points and other evidence of human habitation in Sandia Cave (pictured above during its excavation), just outside of Albuquerque. According to his dating of the earthen layers in which the artifacts were found, the cave had been occupied more than 25,000 years before, making his find the earliest known evidence of human life in the Americas. He named the stone tools he discovered "Sandia points" and the humans who made them "Sandia Man." The discovery made headlines around the world and propelled Frank Hibben to fame and a secure future in academia. (Courtesy Maxwell Museum of Anthropology, University of New Mexico.)

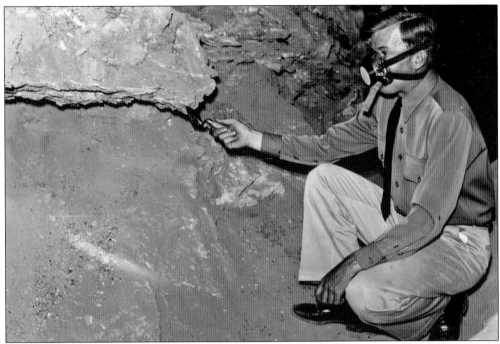

Unfortunately, Frank Hibben (pictured above) and the Sandia Man legacy were soon dogged by rumors of "irregularities." An assertion central to Hibben's analysis of Sandia Man's antiquity was the cohesiveness of the earthen layer in which the artifacts were found, and evidence eventually mounted that the layer was not as undisturbed as Hibben claimed. Among the first to dispute his account was Wesley Bliss, a student who had helped on the Sandia Cave dig, perhaps pictured below among his fellow excavators. Although his criticisms were initially dismissed, by the 1970s, other researchers investigated them and agreed that Hibben's methods were careless, if not outright fraudulent. Four decades after its discovery, Sandia Cave went from "discovery of the century" to embarrassing footnote in Albuquerque history. (Both courtesy Maxwell Museum of Anthropology, University of New Mexico.)

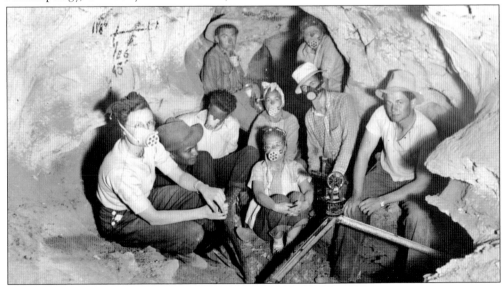

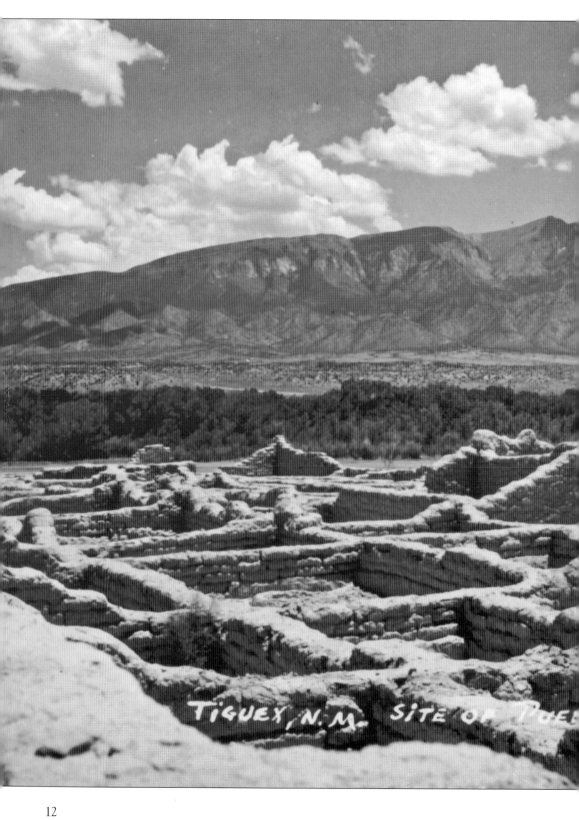

TIGUEX, N.M. SITE OF PUE

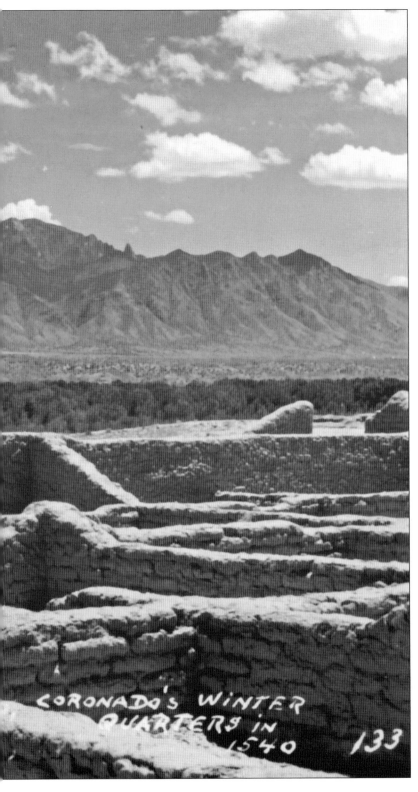

CORONADO'S WINTER QUARTERS IN 1540 133

All human history in the Rio Grande Valley has taken place before the unchanging face of the Sandia Mountains. This 1940 photograph shows the ruins of Kuaua, a Native American pueblo of the Tiguex province that flourished before the coming of the Spanish. Tiguex was made up of some 12 pueblos, most on lands currently occupied by Albuquerque, Corrales, and Bernalillo. When Hernando de Alvarado led a Spanish expedition into the province in 1540, he wrote the following: "This river of Our Lady flows through a very wide open plain sowed with corn plants; there are several groves and there are twelve villages. The houses are of earth, two stories high; the people have a good appearance, more like laborers than a warlike race. . . . they clothe themselves with cotton and the skins of buffalos and dresses of feathers." (Courtesy Nancy Tucker.)

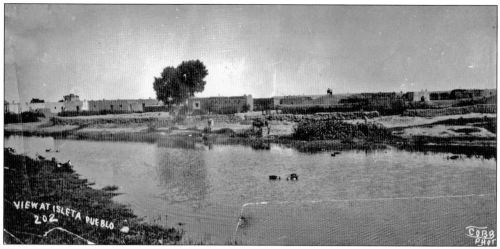

The Tiguex pueblos, like the still-extant Isleta, relied on the Rio Grande for their agricultural lifestyle (pictured in this early-1900s postcard). They grew the traditional "three sisters" crops of corn, beans, and squash, and kept domesticated turkeys. Alvarado's expedition found them to be a peaceful and helpful people, and he recommended that his superior, Francisco Vasquez y Coronado, make camp in the province. (Courtesy CSR PICT 000-119-051.)

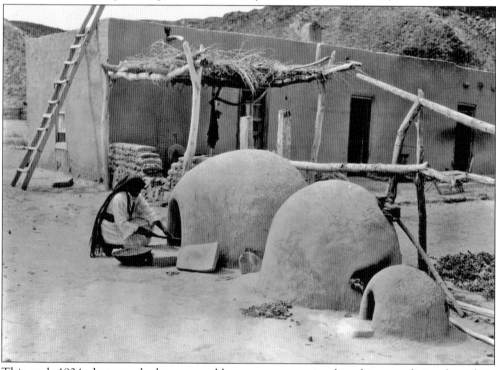

This early-1924 photograph shows a pueblo woman preparing bread in a traditional outdoor oven. Although the people of the Tiguex province were happy to provide food for Alvarado's expedition, his superior officer, Coronado, wore out their hospitality. After forcibly setting up camp at one of the Tiguex pueblos, he began demanding food and goods for his men. A brief series of battles followed, with the Spanish victorious and the Tiguex in retreat. (Courtesy CSR PICT 000-742-0423.)

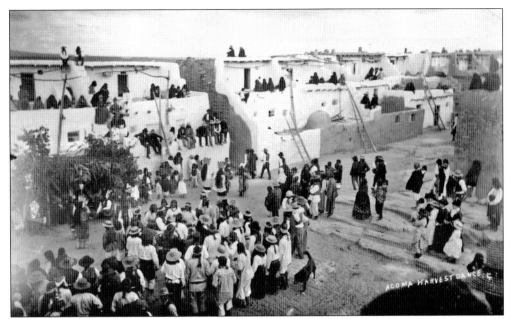

There are many pueblos in New Mexico, and the people of the Tiguex province traded freely among them. Although superficially similar, the pueblos encompass different cultures and languages. The Tiguex province was made up of Tiwa speakers, while one of its nearby trading partners, Acoma Pueblo (pictured above during an 1890 harvest dance), was populated by Keres speakers. (Courtesy CSR PICT 000-119-0502.)

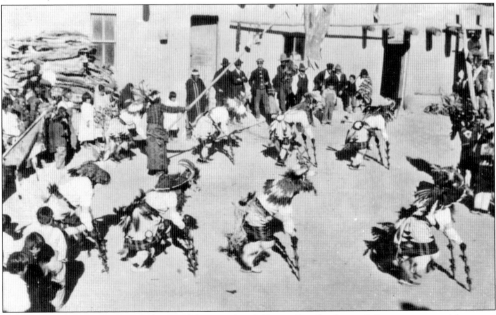

The traditional religion of the Pueblo peoples follows the rhythm of the seasons, with many festivals and dances, such as the unidentified occasion shown above, to mark important times of year. It was a source of consternation for the Spanish, who felt it was their duty to convert the Pueblos to Christianity, a stance that would lead to violence in the New Mexico area as a whole. (Courtesy Nancy Tucker.)

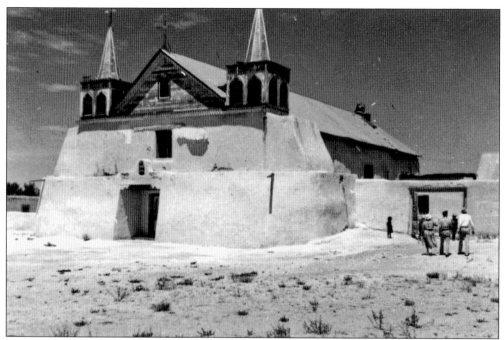

Although the Pueblo peoples never truly gave up their traditional religion, Spanish Catholicism soon became a permanent part of their lives. In many of the pueblos, Spanish missionaries erected churches that still stand, such as Isleta's San Agustin Mission (shown around 1940), built in 1612. (Courtesy CSR William A. Keleher Collection, PICT 000-742-0349A.)

Armed conflict with the Spanish and the ravages of disease eventually forced many of the Tiguex peoples to abandon their pueblos, but their influence lives on in the Albuquerque area. Isleta and Sandia Pueblos are still vital communities, and many sacred sites, such as the petroglyphs on Albuquerque's west mesa (pictured with photographer William Cobb in 1893), remain to remind the current inhabitants of those upon whose lands their city now stands. (Courtesy CSR PICT 000-119-0815.)

Two

La Villa de San Francisco Xavier de Alburquerque

By 1706, the Spanish had already come, gone, and come back again to the Rio Grande Valley and the lands that would someday become Albuquerque. Early settlers had lived and farmed in haciendas along the wooded banks of the Rio Grande until 1680, when their Pueblo Indian neighbors, angry from decades of Spanish mistreatment, rose up in a bloody revolt that forced them to flee to the south. Soon, however, the victorious Pueblo confederation fell into infighting, and when a Spanish military column headed by Diego de Vargas marched north to reconquer Santa Fe and the New Mexico territory in 1692, many of the Pueblos were willing to agree to peace in exchange for greater freedoms under Spanish rule. With the *Reconquista* ensured, Spanish settlers returned to the old dwellings and farms along the river. Spanish villages such as Barelas and Atrisco that would later be absorbed into the city of Albuquerque were founded at this time.

In 1705, following the death of Governor de Vargas, one Francisco Cuervo y Valdez was appointed interim governor of New Mexico. Cuervo had served most of his life as a soldier, methodically rising through the ranks in various New World campaigns, and his appointment to the governorship was an anomaly in a post that was typically used to reward highborn patrons of the Spanish crown. It is likely that Cuervo was all too aware of this incongruity because many of his actions after assuming the governorship seem tailor-made to impress his superiors and, perhaps, to help change his interim appointment to a permanent one.

Among these gestures was the establishment of a new villa, only the third such royally chartered town in New Mexico and an achievement of considerable prestige. In a perhaps revealingly sycophantic move, Cuervo named the villa for his superior, the viceroy of New Spain, the Duke of Alburquerque.

Although Spanish settlers had been living there for decades, and native peoples for millennia before that, on April 23, 1706, with an official proclamation and an unwieldy name, La Villa de San Francisco Xavier de Alburquerque was finally born.

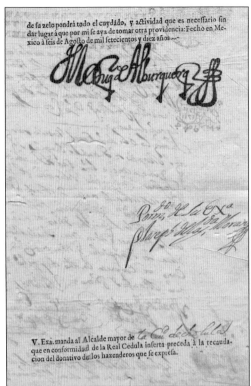

Although the founding of La Villa de San Francisco Xavier de Alburquerque was essentially a publicity move for Governor Cuervo, it was, unfortunately for him, a failed one. His attempts to curry favor with his superior, the Duke of Alburquerque (whose signature is shown here on a c. 1711 document), were undermined when the king of Spain chose a new, permanent governor for the New Mexico territory in July 1706. (Courtesy CSR New Mexico History Collection MSS 349 BC.)

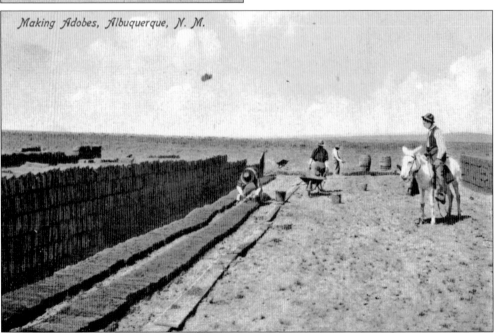

Making Adobes, Albuquerque, N. M.

Due to the area's general lack of timber, the colonists used adobe (baked earth bricks) as their primary building material, as shown in this 1920s postcard. Despite Cuervo's official assurances that the villa possessed a church and governmental buildings, it was later revealed that, in 1706, the villa consisted of little more than a rudimentary town square. (Courtesy Nancy Tucker.)

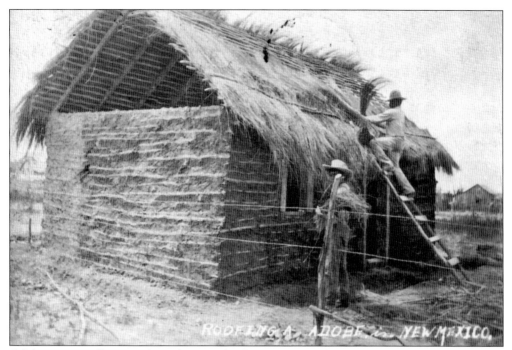

Adobe is an excellent insulator, keeping dwellings warm in the winter and cool in the summer, and thus was perfect for the Rio Grande Valley's erratic climate. Although "New Mexico style" adobe is usually associated with flat-roofed buildings, structures with peaked roofs, such as the one shown in this early-20th-century postcard, were not unheard of. (Courtesy Nancy Tucker.)

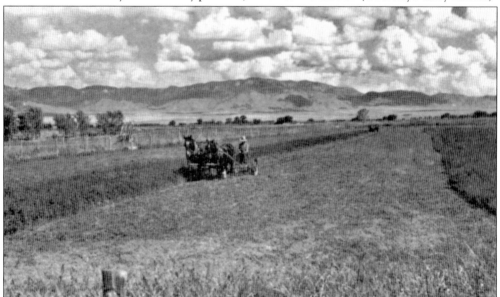

Most residents of the villa lived well outside the town center in a patchwork of farms that grew corn, wheat, and beans along the river. Many of these farms predated the villa, and it is likely Governor Cuervo counted the already extant haciendas among the 35 families of settlers mentioned in his proclamation. This photograph from a 1930s city promotional pamphlet shows a typical small farm near the river. (Courtesy Nancy Tucker.)

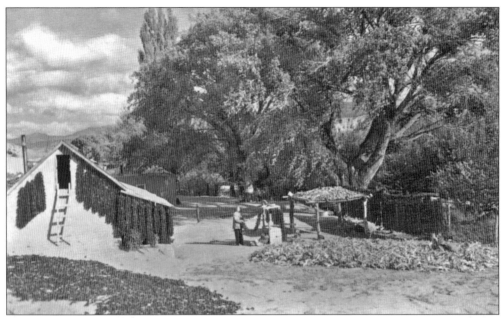

The settlers also grew chile verde, pictured here drying in *ristras* in this 1930s postcard, in order to produce red chile powder. Supposedly brought to the area from Central Mexico by Don Juan de Onate in the 1600s, chile has since become a New Mexican way of life. Before the age of standardization, every region boasted its own variety of the pepper, representing a wide spectrum of heat, color, and pod-shape. (Courtesy Nancy Tucker.)

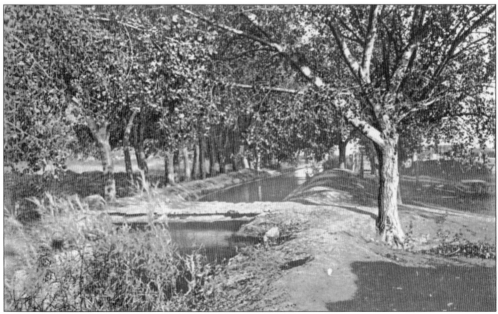

The Rio Grande provided the water, but the residents had to get it to the crops. Soon a network of *acequias* (open canals, shown above in this 1920s postcard) carried water to the farms. Because of its importance, water usage was governed by a complicated legal code, and the community as a whole maintained the *acequias*. (Courtesy Nancy Tucker.)

One of the few pre-villa haciendas to survive both the Pueblo Revolt and the transition to the 20th century, the Don Diego de Trujillo home was built in approximately 1662. A Spanish soldier, Diego de Trujillo fled the home during the Pueblo Revolt. In the intervening years, the ancient home has been a part of Albuquerque's history. This photograph, taken in 1915, shows the building as it appeared soon after the ownership of Franz Huning, one of Albuquerque's most influential figures during the late 19th century. Today the Manzano Day School utilizes the home, as it has since 1938. (Courtesy CSR Gish Collection PICT 000-645-0041.)

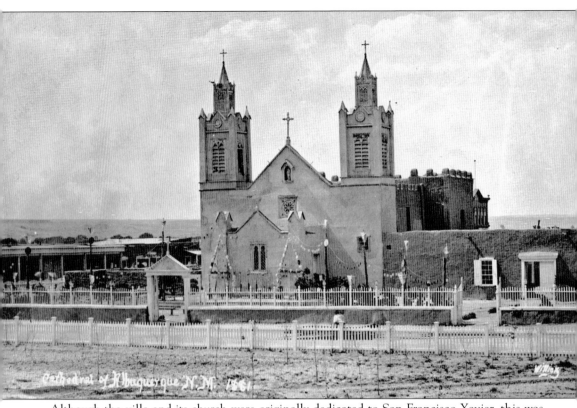

Cathedral of Albuquerque N.M. 1861

Although the villa and its church were originally dedicated to San Francisco Xavier, this was in defiance of a royal decree that the next villa founded should be named in honor of King Felipe V. Officials in Santa Fe soon corrected the mistake and changed the name of the villa to San Felipe de Alburquerque. However, the residents of the villa were still attached to San Francisco Xavier and continued to consider him their patron saint for decades after the official change. It was not until 1776 that an ecclesiastical inspector forced the residents to adopt San Felipe de Neri as patron. In the winter of 1792, the original church on the plaza collapsed, and the residents set about constructing a new one. This 1861 photograph shows the second church, after several remodelings and restorations, looking similar to how it appears today. (Courtesy CSR PICT 000-742-0795.)

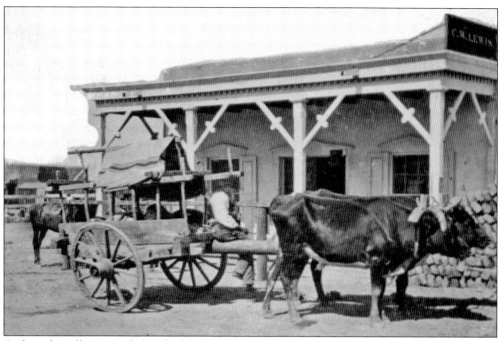

At first, the villa's central plaza had few permanent residents. Instead the farmers from the nearby haciendas would gather their families and supplies on Saturday evenings and, using horse- or oxen-drawn carts, as pictured in this 19th-century photograph, would drive them to "Sunday residences" in the town center in order to have easier access to the church the next morning. (Courtesy CSR PICT 000-119-0588.)

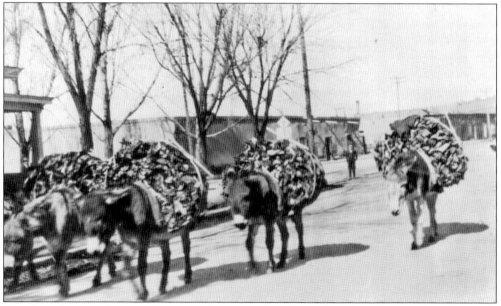

The plaza also served as a market where farmers and residents of nearby villages and pueblos, such as Atrisco, Isleta, and Barelas, could trade various goods. In this 1925 photograph, a mule train, perhaps from one of the mountain communities on the east side of the Sandias, brings wood to the plaza for trade. (Courtesy Nancy Tucker.)

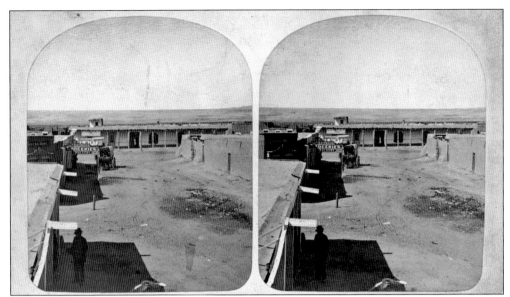

Raids by the Apaches and Comanches required that the town center serve as protection for the colonists. The plaza was laid out in a defensive pattern, with long buildings serving as makeshift walls, as seen in this 19th-century stereogram. Throughout the 18th century, Spanish soldiers were stationed at the villa. However, following the Mexican War of Independence, defense was left in the hands of citizen militias. (Courtesy CSR William A. Keleher Collection PICT 000-742-0558.)

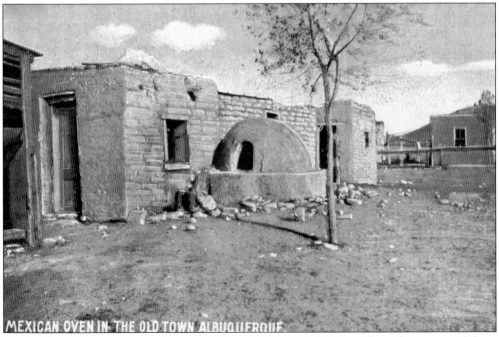

Gradually, as the town center became vital to the lives of the Spanish settlers, more of them began to build permanent dwellings on or near the plaza. Along with their homes, the settlers used adobe to build outdoor ovens called *hornos* (as seen in this early-20th-century photograph) in which they baked bread for their families. (Courtesy Nancy Tucker.)

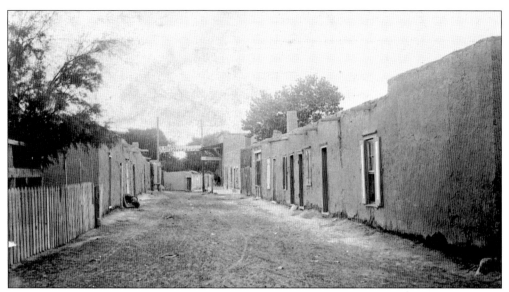

As the 18th century came to a close, growing troubles in Mexico City caused the rulers of New Spain to turn their attention from New Mexico and, it seemed, to nearly forget about the tiny Villa de Alburquerque altogether. One of the villa's sleepy streets is shown around 1892. After the Mexican War of Independence evicted the Spanish from Mexico in 1810, a subsequent series of armed conflicts tore through the newly independent country and further removed the New Mexican lands from the concerns of its far-away government. The villa found itself neglected by its rulers, and resentment toward the "Mexicans" began to grow. It must have been quite a boon to the villa's pride then, when one of their own, Manuel Armijo rose to become governor of New Mexico in 1827. The *c.* 1890 photograph below shows Armijo's childhood home near the town center. (Above courtesy CSR 000-119-0586; below courtesy Nancy Tucker.)

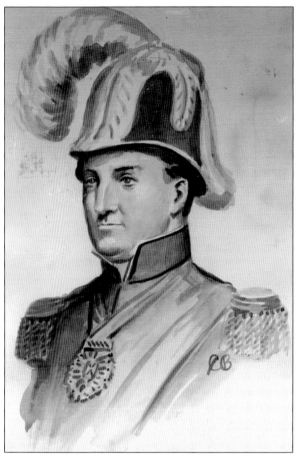

Armijo (pictured at left in this c. 1853 painting) served three terms as governor of New Mexico and was easily the most influential and controversial New Mexican figure during the period of Mexican rule. His first term ended with his resignation, apparently to avoid an investigation into alleged improprieties in his leadership. He rode the bloody wave of a revolution into his second term, during which he thwarted an attempt by the new Republic of Texas to claim New Mexican land. His third term was his last and, indeed, the last term for any Mexican governor of New Mexico. A border dispute with the United States of America over the newly admitted state of Texas precipitated the Mexican-American War, and in its wake, the Villa de San Felipe de Alburquerque would be changed forever, as is reflected in the c. 1890 postcard below of the village's transformed plaza. (Left courtesy CSR William A. Keleher Collection 000-742-0001; below courtesy Nancy Tucker.)

The Plaza Old Town Albuquerque, N. M.

Three

THE AMERICANS

When Gen. Stephen Watts Kearny and his Army of the West took possession of New Mexico in 1846, he found a populace that offered little armed resistance to the American invaders. Nowhere was this more apparent than in the small Villa de Alburquerque, where decades of neglect following the Mexican War of Independence had sowed bitter resentments between the colonists and their ostensible rulers in Mexico City. In fact, when Kearny and 700 soldiers arrived in the villa, the local militia greeted them with a resounding cheer and a 21-gun salute.

At first, the Americans used La Villa de Alburquerque (or *Albuquerque* as their fumbling tongues increasingly referred to it) as a military outpost from which the occupiers shored up their holdings against raiding Apaches and a few short-lived New Mexican insurgencies. It is notable that residents of the villa did not take part in these brief revolts. Though some of the soldiers were known for their unruly behavior and unkempt dress, many of the villa's citizens appreciated both the protection they offered from the Apaches and the increased commerce they brought with them.

In 1853, a harbinger of things to come arrived in the newly American villa: an expedition of U.S. Topological Engineers scouting the area for a possible railroad connecting Arkansas to California took five weeks of rest in the village while awaiting the release of supplies necessary to complete their journey westward. One wonders if the citizens of La Villa de Alburquerque could have realized that, though so much change had already swept through the once sleepy town, this group of unassuming engineers signaled a far greater change on the horizon than even the carousing American soldiers who drank their wine and made eyes at their daughters.

But it would be another three decades before the railroad would put its imprint on the city forever. Before that, however, the villa would briefly find itself beneath yet another flag: that of the Confederate States of America.

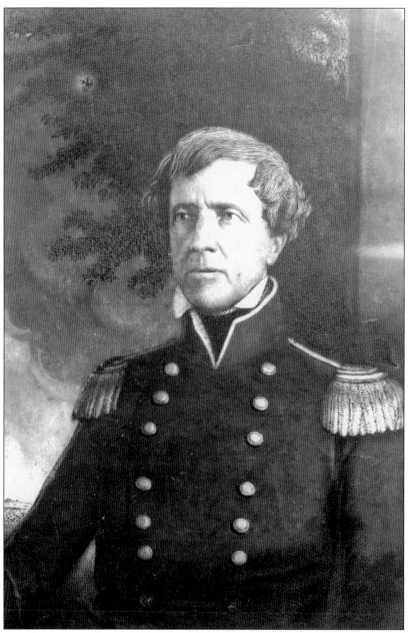

There was no climactic confrontation between General Kearny (pictured) and Governor Armijo's New Mexican army. The governor, dispirited by the poor condition of his troops (consisting of a ragged collection of regulars, militiamen, and conscripted Pueblo Indians) and a lack of support from his superiors in Mexico City, abandoned the fight before the enemy was in view and beat a hasty retreat to Mexico. Essentially unopposed, Kearny easily took possession of the territory. For the next two decades, the Villa de Alburquerque was used as an American military outpost. It is difficult to quantify the effect this had on the lives of the villagers. Certainly, the rhythms of pastoral life along the river continued much as before. Commerce, however, was indisputably increased, and a moneyed merchant class began to rise in the villa. (Courtesy CSR William A. Keleher Collection 000-742-0067.)

In March 1862, the U.S. Civil War came to the Villa de Alburquerque. A force of some 2,500 Texas volunteers, led by Gen. Henry Hopkins Sibley (pictured at right), easily captured the town because Union troops had been concentrated elsewhere along the Rio Grande. As the Confederate flag was hoisted over the villa, a band played "Dixie," and the Texans seized supplies from the homes of the villa's residents. (Courtesy CSR William A. Keleher Collection 000-742-0139.)

Not all of the villagers were unwilling to support the Confederate troops. Manuel and Rafael Armijo, brothers who owned one of the region's largest mercantile outfits, happily allowed General Sibley to take up residence in their home. The brothers supplied the Texans with goods and served as ersatz secretaries for Sibley, transcribing the general's messages and orders. An example is reproduced below. (Courtesy CSR John L. Gay Collection MSS 10BC.)

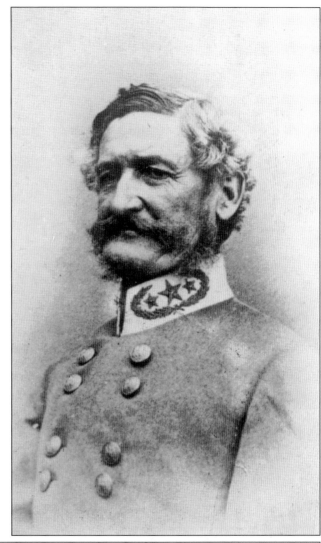

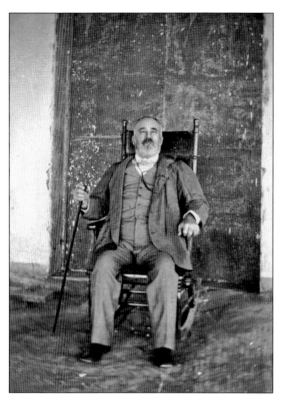

Other villa residents were notably less pleased about the occupation. Don Felipe Chavez (shown here in a c. 1900 photograph), another local merchant, had armed his household in expectation of the Confederates' arrival. As indicated in the previously reproduced message from General Sibley, he was soon forced to surrender his weapons. (Courtesy CSR Felipe Chavez Family Pictorial Collection PICT 000-010-002.)

The Confederate campaign in New Mexico was a brief one. The Texas volunteers quickly captured Santa Fe and began marching north toward Fort Union. In Glorieta Pass, they met a force of Colorado and New Mexico Union volunteers, whom they defeated in a short battle memorialized by the plaque at right. However, other Union agents used the opportunity to set fire to the lightly guarded Confederate supply wagons. (Courtesy CSR William A. Keleher Collection PICT 000-742-0140.)

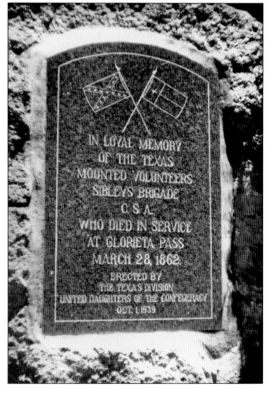

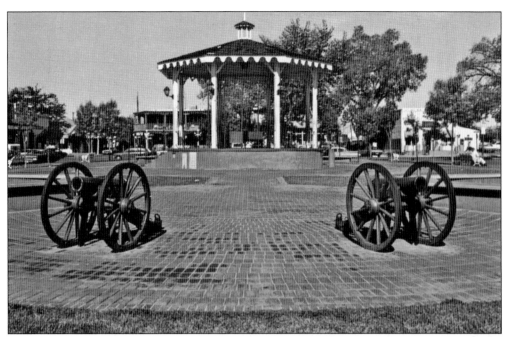

Without supplies, the Confederates retreated back to Alburquerque. However, Col. Edward Canby's 1,200 Union troops arrived outside of the villa first and begun shelling the small group of Confederates who had remained behind. As his weary soldiers began trickling into the village under Union cannon fire, Sibley realized there was little chance of defending Alburquerque. On April 12, he lowered the Confederate flag, buried several cannons in a nearby corral (two of which, pictured above, remain in the Old Town plaza), and retreated from the villa. Accompanying the fleeing force were the Armijo brothers, who feared repercussions for their actions. As this 1864 receipt for the sale of "negro slaves" to Rafael Armijo shows, the brothers remained sympathetic to the Confederate ideals until the end of the war. (Above courtesy Nancy Tucker; right courtesy CSR John L. Gay Collection MSS 193 BC item 24.)

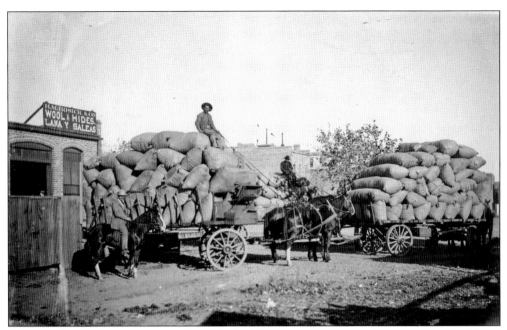

After the Civil War, commerce in the Villa de Alburquerque continued to grow. Wool had been an important New Mexican commodity for generations, and now that the trade was open to the rest of the United States, the industry flourished. The villa was well positioned to serve as a crossroads for wagon freighting, and wool merchants such as the Hosick Company, pictured above about 1880, began to reap the profits. (Courtesy CSR PICT 000-119-0596.)

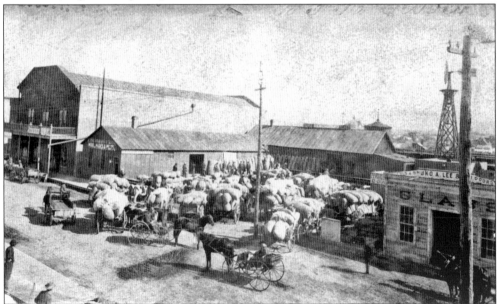

The mining boom in Colorado and California raised the demand for wool clothing to levels never before seen in New Mexico, and soon the mesas outside the villa were thronging with sheep. The sudden need for storage warehouses and freight depots precipitated an early building boom outside the villa's town center, which was invigorated by the coming of the railroad in 1880. This 1890 photograph shows busy warehouses near First Street. (Courtesy CSR PICT 000-119-0596.)

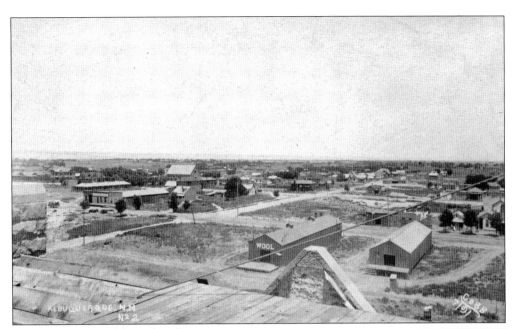

With the coming of the railroad, the wool industry truly began changing the town's landscape and culture. The quiet village was now a profitable center of industry that became known throughout the United States by its newly anglicized name, "Albuquerque." Pictured above are warehouses built by David Keleher, whose son William would become one of the city's most respected attorneys and historians. (Courtesy CSR PICT 000-119-0554.)

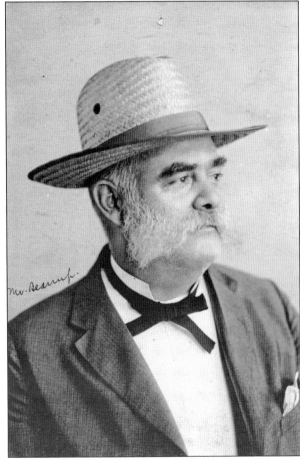

John Bearrup, pictured here, made his fortune in the Albuquerque wool boom by opening a wool scouring cooperative in the late 19th century. A devout socialist, his workers were also shareholders in the enterprise, and he was quoted in a 1906 newsletter as saying that he saw "no reason why his cooperative factory should not be the nucleus of a cooperative town." His vision of the future did not manifest. (Courtesy CSR PICT 000-119-0233.)

Franz Huning, an immigrant from Hanover, Germany, arrived in Albuquerque in 1852. Huning, pictured here around 1860, had worked as a bullwhacker on a wagon train and an unsuccessful merchant in the village of San Miguel, and he was destined to become one of Albuquerque's most influential and successful figures. Upon his arrival, he worked briefly at a store on the villa's plaza before embarking on several of his own business ventures. (Courtesy CSR William A. Keleher Collection PICT 000-742-0479.)

Huning soon opened his own store, which he ran with his brother Charles. As it became more successful, he expanded the business to include freight wagon trains that plied the route between Albuquerque and Missouri. He also opened La Molina ("The Mill", pictured below) in 1863, which would become one of the most successful gristmills in the area. (Courtesy CSR Gish Collection PICT 000-645-0045.)

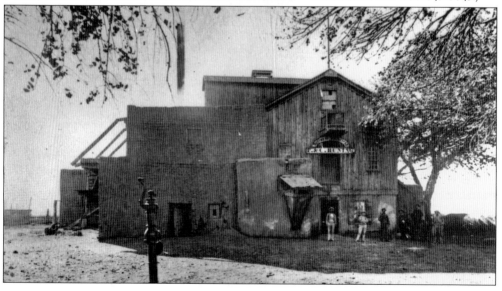

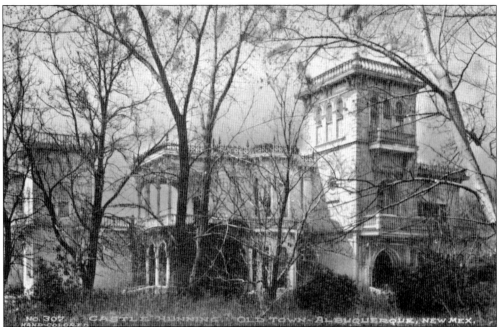

Huning's businesses were so successful that in 1883 he built one of Albuquerque's most fondly remembered and incongruous landmarks. Castle Huning, pictured above, was just that, a veritable palace built of *terrones*, or sod bricks, designed to recall the castles of Huning's home country. Although it was demolished in the 1950s, Castle Huning made a permanent mark on Albuquerque's identity and is still fondly remembered a half-century since its loss. (Courtesy Nancy Tucker.)

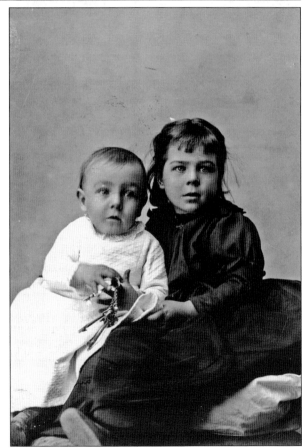

Another of Franz Huning's contributions to Albuquerque's identity was through his family. Pictured at right holding her brother Harvey is Huning's granddaughter, Erna Fergusson. Erna would grow to become one of Albuquerque's most prominent historians, and her ecstatic prose conveyed her love of the city in a way few have matched since. (Courtesy CSR PICT 000-119-0324.)

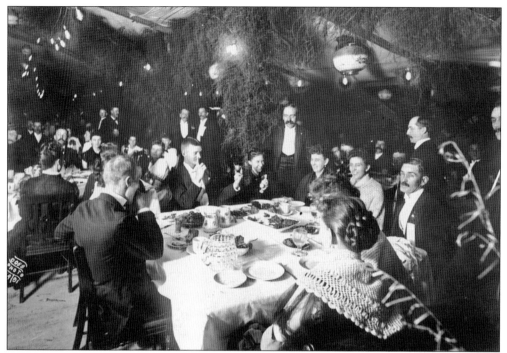

Suddenly, Albuquerque's mercantile success had given birth to a moneyed class of recently arrived, or newly made, businessmen. Believing there was still more opportunity to be had in the once quiet villa, they formed an organization in order to promote Albuquerque among other moneyed Easterners. In this 1891 photograph, members of the Commercial Club gather for a banquet and meeting. (Courtesy CSR PICT 000-119-0764.)

Members of the Commercial Club and other important figures in the newly American Albuquerque organized Territorial Fairs for both the enjoyment of the local population and the promotion of the town. This photograph, from the first such celebration in 1882, shows members of the nascent Albuquerque Fire Department performing for a crowd at the newly built fairgrounds just west of the plaza. (Courtesy CSR PICT 000-119-0467.)

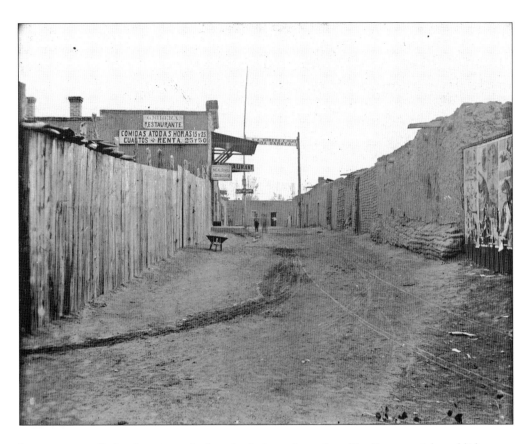

In no time at all, the Americans had made their mark on the villa. Commercial establishments in the streets around the plaza, such as this restaurant and hotel (pictured above around 1890) now advertised in both English and Spanish, reflecting the diverse clientele arriving regularly in the town. Saloons and dance halls opened to serve transient bullwhackers coming into town with the constant stream of wool-laden freight wagons. An even more undeniable sign of the times had also appeared in dusty streets of the villa: the federal post office was located on Zamora Store, shown below in this *c.* 1880 photograph. (Both courtesy CSR; above William A. Keleher Collection, 000-742-0557; below PICT 000-119-0587.)

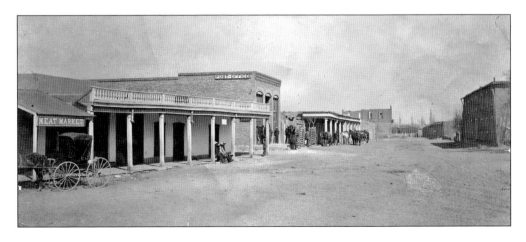

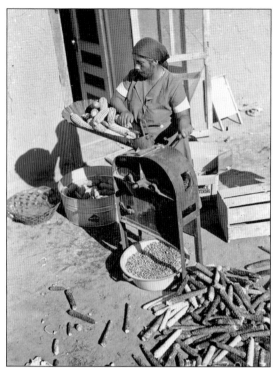

Although businesses remained concentrated around the plaza, the increased trade also affected life in the haciendas along the river. As merchants brought tools, such as the corn-processing machine in this 1880 photograph, and goods to the farms, it became obvious that life in the Rio Grande Valley would never be the same. Though the traditions of the Spanish people remained strong, the proximity of American enterprise made change inevitable. (Courtesy CSR Lauren C. Bolles Collection 000-493-0124.)

More than ever before, Spanish residents of the villa, such as the merchant in this 1890s photograph, now entered into the world of commerce. Grocery stores and butcher shops presented a natural transition for those with an agricultural background, and the more politically powerful or wealthy opened banks and mercantile outfits. Florencio Zamora, Cristobal Armijo, Jesus Romero, and Ambrosio Armijo were among the important names in the burgeoning town. (Courtesy Nancy Tucker.)

Throughout the second half of the 19th century, Albuquerque's growth continued at an unprecedented rate. New buildings clustered around the town square and sprang up in the unoccupied land to the east. As these late-1800s photographs of the far-flung Huning Heights development show, multistory wood and brick homes would soon become the norm. (Courtesy CSR PICT 000-119-1549.)

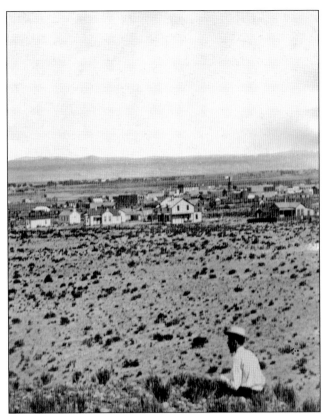

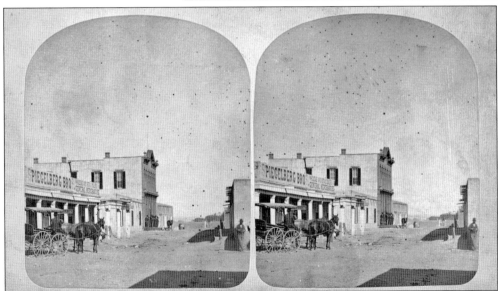

This 1880s stereoscopic photograph shows the Spiegelberg Brothers grocery store near the town center. The increase in commerce and the influx of businessmen from the East had well and truly begun to change the culture and character of the villa throughout the mid-18th century, and the process would soon become even more dramatic and irreversible. (Courtesy CSR William A. Keleher Collection 000-742-0531.)

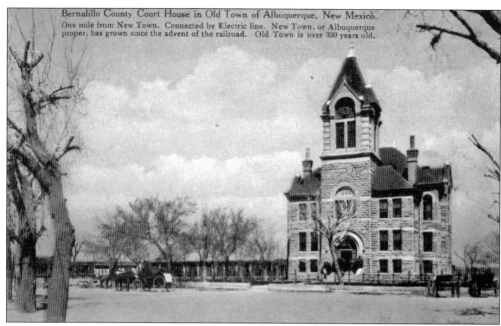

Bernalillo County Court House in Old Town of Albuquerque, New Mexico.
One mile from New Town. Connected by Electric line. New Town, or Albuquerque
proper, has grown since the advent of the railroad. Old Town is over 300 years old.

In the 1870s, representatives of the Atchison, Topeka, and Santa Fe Railroad (AT&SF) scouted land near the Albuquerque plaza but found it too expensive. Instead they made a secret deal with certain Albuquerque businessmen, including Franz Huning, to quietly purchase cheap land approximately one and a half miles east of the town. Believing the railroad would mean incredible opportunity for profit, the men did as they were asked and subsequently leased the land to the AT&SF for $1 per acre. Although the construction of the Bernalillo County Courthouse (above) on the plaza indicates that it was still considered the town center in 1886, Albuquerque's commercial growth was now tied to the railroad, and the railroad lay to the east. The future of Albuquerque would now belong to New Town (pictured below in 1890), and the villa's town center would become increasingly irrelevant. (Both courtesy Nancy Tucker.)

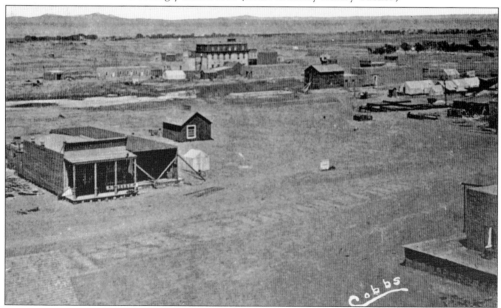

Four

THE RAILROAD

On April 22, 1880, some 175 years after the founding of La Villa de Alburquerque, the first coal-burning train engine pulled into a station of the newly constructed Atchison, Topeka, and Santa Fe Railroad (AT&SF). Due to tense land negotiations, the depot was one and a half miles outside of the villa, in a spot of empty level land just before the rolling sand hills that filled the gradually rising expanse at the foot of the Sandia Mountains. As bands played fanfares and dignitaries delivered speeches in English and Spanish from a flatbed railcar, the town we know today as "Albuquerque" experienced another of its many births.

Other than the town's initial founding, there have been few events with as profound an impact on Albuquerque's character and growth than the arrival of the railroad so far from the villa. The decision to lay track in an undeveloped area allowed moneyed interests from outside the state to quickly position themselves to take full advantage of the new railroad and caused the villa to enter a swift decline as commercial ventures relocated to the new economic center. Additionally, the once-profitable wagon freight industry that had bolstered the villa's economy throughout the mid-19th century became suddenly and starkly obsolete. It is not an exaggeration to say the arrival of that single train in the empty sand hills marked the end of the villa's economic and geographical importance in the city's development, although its cultural influence would remain vital well into the present day.

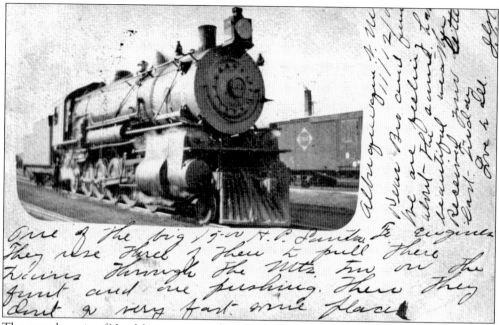

The rugged terrain of New Mexico presented serious challenges to the development of the Atchison, Topeka, and Santa Fe Railroad. Among other concessions, the main line was forced to bypass its namesake, Santa Fe, which could only be reached by a spur from Lamy. As the sender of this 1906 postcard reports, three powerful engines were required to move the passenger trains through the mountainous regions surrounding Albuquerque. (Courtesy Nancy Tucker.)

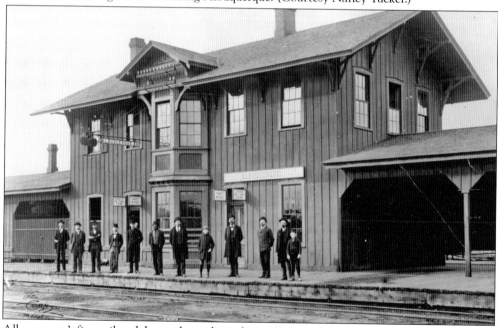

Albuquerque's first railroad depot, shown here about 1890, was hardly an impressive affair. Indeed, although men like Franz Huning held out faith for its future, the area around the station was initially slow to develop, and little besides the wooden depot greeted passengers for several years. (Courtesy CSR William A. Keleher Collection 000-742-0623.)

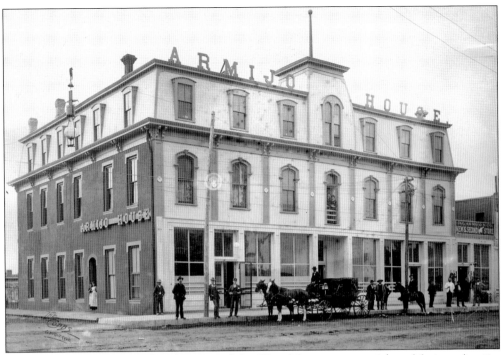

One early entrepreneur to take advantage of New Town's business potential was Mariano Armijo. Armijo, the son of a wealthy merchant, built Albuquerque's first luxury hotel, the Armijo House, shown here in 1886. During its years of operation, it hosted several famous visitors, including Pat Garrett, who had recently killed Billy the Kid. Garrett supposedly had a tense conversation with Joseph Antrim, the Kid's brother, in the hotel bar. (Courtesy CSR William A. Keleher Collection 000-742-0469.)

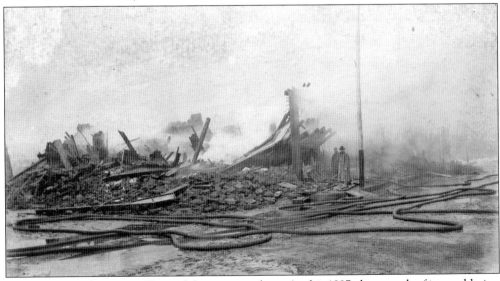

Unfortunately, the Armijo House did not survive long. As this 1897 photograph of its smoldering ruin shows, it fell victim to one of New Town's many fires. Fire was a continual problem for early Albuquerque, and several landmarks were lost to it, including the Highland and San Felipe Hotels. (Courtesy CSR PICT 000-119-0746.)

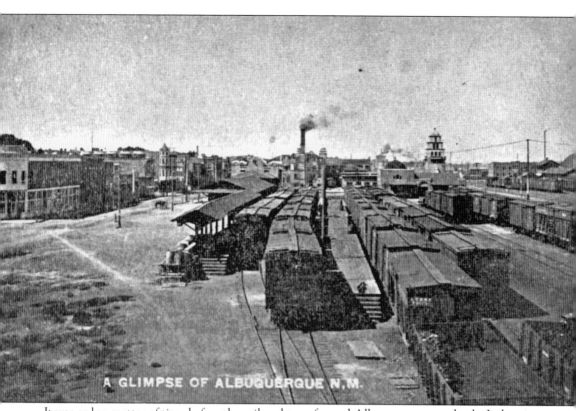

A GLIMPSE OF ALBUQUERQUE N.M.

It was only a matter of time before the railroad transformed Albuquerque completely. Industries such as wool and livestock were renewed by the economic opportunities the rails brought, while others, like timber, were suddenly viable to a degree never before seen. Albuquerque grew to become an economic powerhouse after the development of the New Town revitalization. Its residents (mostly recent arrivals to the territory) increasingly thought of themselves as separate from the villa, which they began to refer to as "Old Town." This early-20th-century postcard shows Albuquerque's rail yards in their golden age—a crowded, smoky chaos busy with the comings and goings of various freight trains. (Courtesy Nancy Tucker.)

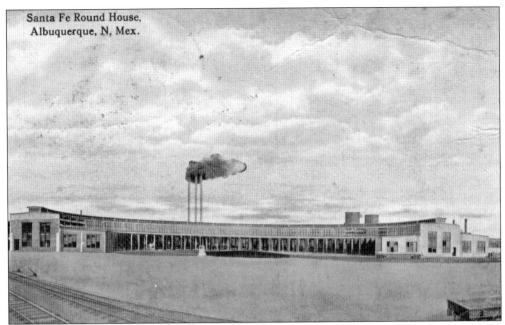

Santa Fe Round House,
Albuquerque, N, Mex.

The railroad itself also created economic opportunities through its maintenance needs. In 1881, Barelas, a village just south of New Town Albuquerque, was chosen to be the site of the AT&SF Railroad's machine shops and roundhouse (shown here after its 1915 expansion). The early-1900s photograph below shows two men, perhaps from Barelas, working in one of the site's many shops. The shops had the effect of both providing jobs to the Barelas community and also disrupting the traditional agricultural way of life. When the shops closed in 1970, Barelas suffered a massive economic decline from which it has only recently begun to recover. Currently, the buildings remain abandoned and empty, although a movie studio has plans to develop the site. (Both courtesy Nancy Tucker.)

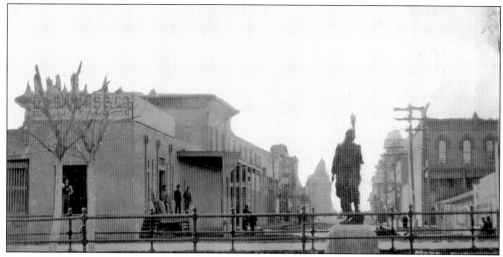

By 1886, when this photograph of Gold Avenue outside the railway depot was taken, the new economic reality the railroad brought with it had become an unavoidable fact. New Town was a rapidly growing city, boasting several hotels, many saloons, and all the moral turpitude of a frontier town. Prostitution and gambling were legal and ubiquitous, especially in the area referred to as "Hell's Half-Acre." Gunfights were not unheard of. (Courtesy CSR William A. Keleher Collection 000-742-0545.)

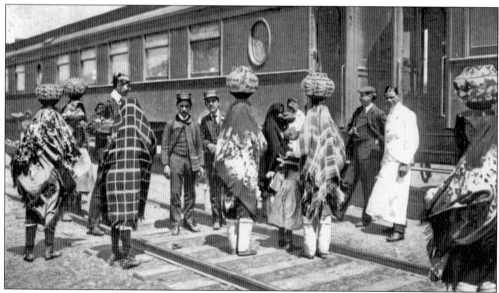

As increasing numbers of Easterners plied the long journey to New Mexico, many passengers became enchanted by the mystique of the Southwest. The AT&SF Railroad was happy to accommodate these curious tourists and arranged stopovers on the Pueblo lands so they could trade for Native American goods. This photograph from the late 1880s shows one such stopover. (Courtesy Nancy Tucker.)

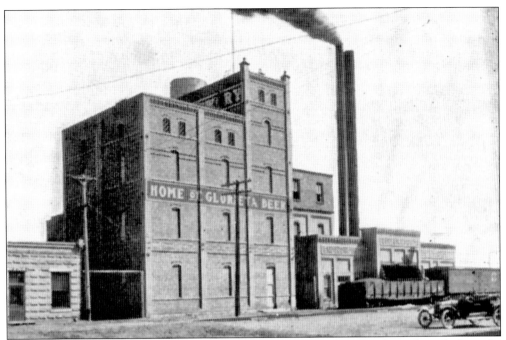

Along with the wool and livestock industries, other businesses benefitted significantly from the railroad boom. Pictured in the above promotional photograph is the Southwestern Brewery and Ice Company, which utilized Albuquerque's central location to sell Glorieta beer throughout the Southwest. The beer was sold from 1883 until Prohibition shut down the brewing operation in the 1920s. (Courtesy author's collection.)

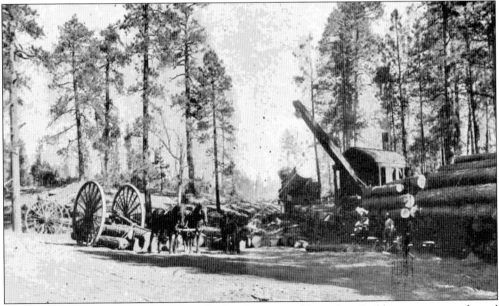

The railroad made timber operations in the Southwest possible, and profitable, at an unprecedented scale. Organized in 1902, the American Lumber Company would soon become one of the largest employers in Albuquerque. Its operations in the New Mexico Mountains are shown in this early-1900s photograph from a promotional brochure. (Courtesy author's collection.)

As industry flourished in New Mexico, stark dichotomies arose between the traditionally slow pace of life in the territory and the modern machinery and massive scale operations the growing economy brought with it. Postcards, such as the 1903 example above, humorously depicted the use of outdated methods in the territory to appeal to Easterners' romantic notions. Conversely, the photograph below, from an early-20th-century promotional brochure, emphasizes the city's use of large-scale rail operations to portray it as a modern center of industry with opportunity aplenty. This two-minded approach to "selling" the region—portraying a relaxed otherworldliness for tourism and an aggressively modern economic stronghold for the purposes of attracting businesses—is still common today. (Above courtesy Nancy Tucker; below courtesy author's collection.)

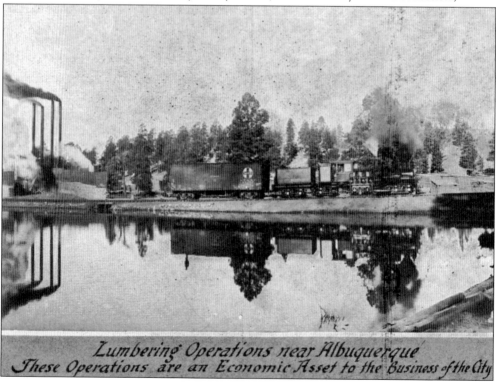

Lumbering Operations near Albuquerque
These Operations are an Economic Asset to the Business of the City

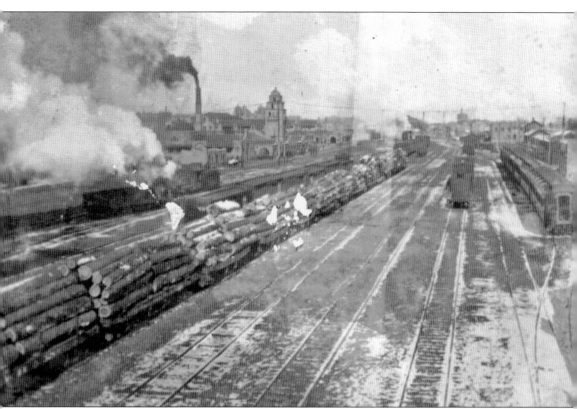

The American Lumber Company primarily logged in the Zuni Mountains in northwestern New Mexico. There the company held a 300,000-acre tract that had been wrested from public ownership through the shrewd manipulations of the AT&SF Railroad. The land was originally to have been held in trust for education. The lumber company also owned a sawmill in Albuquerque that processed 325,000 feet of wood per day. Although its operations were based in New Mexico, its ownership was entirely made up of residents of other states. This c. 1905 photograph gives some idea as to the amount of timber the company processed in Albuquerque. (Courtesy Nancy Tucker.)

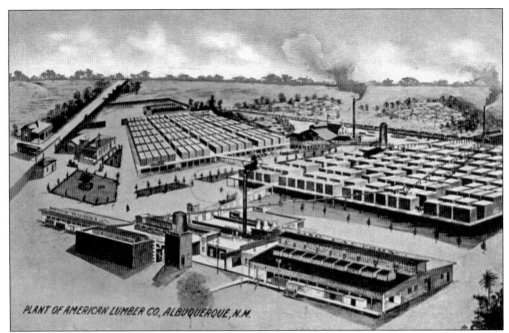

PLANT OF AMERICAN LUMBER CO., ALBUQUERQUE, N.M.

By 1907, the American Lumber Company was promoting itself as "the greatest individual enterprise in New Mexico." Its processing plant (shown here in a *c.* 1910 postcard) covered 110 acres and employed some 1,200 men. In addition to the sawmill, the company also operated a box factory and a sash and door enterprise. (Courtesy Nancy Tucker.)

Leaving Albuquerque Homeward Bound. → *Like hell*

The railroad transformed Albuquerque into a city of explosive growth and opportunity. Increasing numbers of people from both within the territory and outside it arrived daily, and many of them were choosing to stay and make a life for themselves. Apparently the sender of this 1905 postcard was among them. (Courtesy Nancy Tucker.)

Five

THE ALVARADO

Few structures have made such an impact on any city as the Alvarado Hotel made on Albuquerque, and few structures have left such a hole with their passing. Has Albuquerque ever recovered from its loss? True, a beautiful transportation center now stands in its place, recalling its graceful lines and ostentatious grandeur, but what Albuquerquean can honestly say that the glorified bus terminal's presence can ever do more than remind us of that long-ago hotel and the thoughtlessness that led to its destruction? Three decades too late, Albuquerque decided to value its history and tried to correct a mistake that can never be fixed.

The Alvarado, like New Town Albuquerque itself, was a product of the railroad. More than that, it was an omen that the city's rebirth was successful, that Albuquerque would not just survive into the future but thrive. It was a celebration of New Mexico's mystique and a beacon for those Easterners who wished to discover the newly accessible parts of their country.

The Alvarado was not just a hotel, but also a self-contained vision of the Southwest, a veritable diorama with New Mexico as its theme. Native American artisans toiled for Eastern tourists, and New Mexico history was presented as a series of exhibits whose primary purpose was to sell merchandise. The truly adventurous tourist could book a "horseless carriage" tour of Hispanic or Native American sites and view their new countrymen through the glass of an autobus window.

The Alvarado is an integral part of Albuquerque's story and a reminder of a time when the railway brought the world to our doorstep, when Albuquerque thrived not in spite of its Southwestern locale and history, but because of it.

In 1970, the wrecking ball swung into the Alvarado's central walls, and Albuquerque lost a part of itself forever.

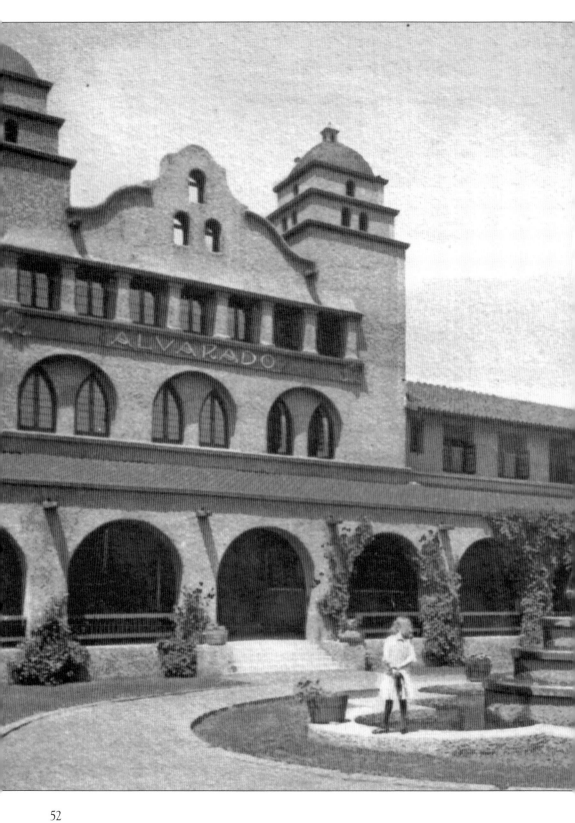

The Alvarado. Albuquerque, N. M.

No. 1360
Hand Colored.

The Alvarado was completed in 1902 at a then-impressive cost of $100,000. One of the crown jewels of the Harvey House Company, the building housed the new AT&SF Railroad depot, a saloon, several barbershops (termed "tonsorial parlors" in the promotional material), and a Native American museum, in addition to the 89-room hotel itself. This c. 1905 postcard showcases the hotel's plaza courtyard, toward which all of the rooms faced. There was also a rooftop garden that afforded a view of the Sandia Mountains. An early promotional pamphlet for the hotel bragged, "[the Alvarado] invites cheerfulness and relaxation in its spacious halls and secluded gardens." (Courtesy Nancy Tucker.)

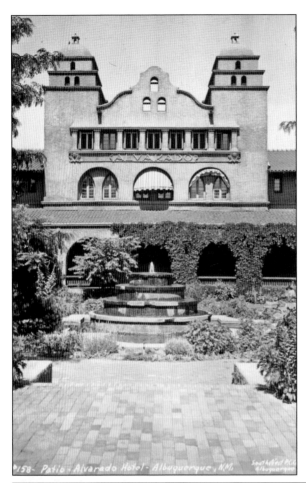

*158- Patio- Alvarado Hotel- Albuquerque, N.M.

The Alvarado's striking architecture was designed by Charles F. Whittlesey, chief architect of the Harvey House Company. Whittlesey borrowed many design elements from the Spanish missions in California, a motif found in many of the Harvey Hotels. This early-1900s photograph shows the curved gables endemic to the style. (Courtesy Nancy Tucker.)

A writer from the *Topeka Daily State Journal* who covered the hotel's opening paid particular attention to the Alvarado's many electric lights (pictured below), which were unusual in the largely rural Southwest. "The lighting of the building is something grand . . . a very extensive system for a building of its size, the cost being about $6,000.00," he wrote. This postcard shows the Alvarado decorated with lights for the 1911 State Fair. (Courtesy Nancy Tucker.)

TRADE MARK

Post Card Views
THE INDIAN BUILDING
ALBUQUERQUE, NEW MEXICO.
Compliments of Fred Harvey

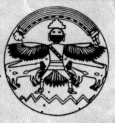

ALL TRAINS STOP TWENTY-FIVE TO THIRTY MINUTES AT ALBUQUERQUE. CONDUCTORS WILL GIVE ADVANCE NOTICE IN THE INDIAN BUILDING OF THE DEPARTURE OF TRAINS.

An authorized representative of The Indian Building will be on this train for a few hours in the vicinity of Albuquerque. He will show and explain blankets, silverware and other Indian handicraft. All articles are guaranteed as to price, etc., the same as in The Indian Building.

The Fred Harvey Company promoted a romantic view of the Southwest and its cultures, and capitalized on that view at every opportunity. As a subsidiary of the AT&SF Railroad, it was afforded a unique opportunity to market to passengers. As explained on the packaging of this complimentary set of postcards, "authorized representatives" of the Alvarado boarded the train outside of Albuquerque to advertise the merchandise available in the hotel's Indian Room. (Courtesy Nancy Tucker.)

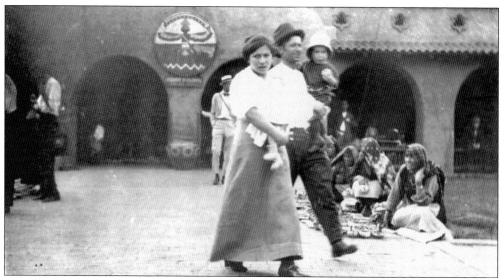

The Fred Harvey Company was quite savvy about the exotic appeal the Southwest held for Eastern tourists and was quick to turn New Mexico's cultural identity into an exploitable commodity. Arrivals at the Alvarado Depot, such as the young family shown in this early-1900s photograph, were greeted by Native American merchants offering a variety of goods for sale. (Courtesy Nancy Tucker.)

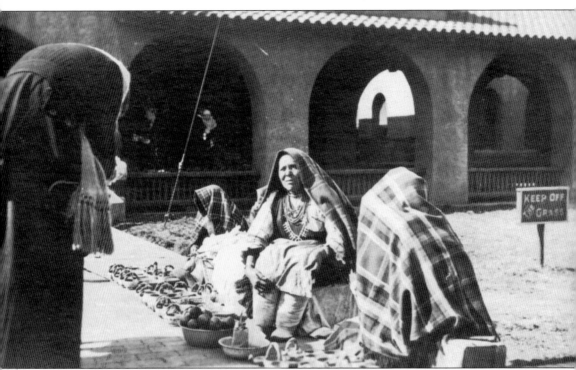

This commodification of traditional New Mexican culture was central to the Harvey business model. The railroad had opened the West, and wealthy Easterners were eager to experience it, but many potential tourists were also intimidated by the unfamiliar countryside and seemingly foreign cultures of the territories. The Harvey Houses offered them a packaged "adventure," where they could interact with Native Americans (such as the merchants shown in this c. 1910 real-photo postcard), peruse and purchase Southwestern arts and jewelry, and browse through a museum on Native American history, all without leaving the depot. The idea proved immensely popular, earning Fred Harvey, the company's founder, the title of "Civilizer of the West." (Courtesy Nancy Tucker.)

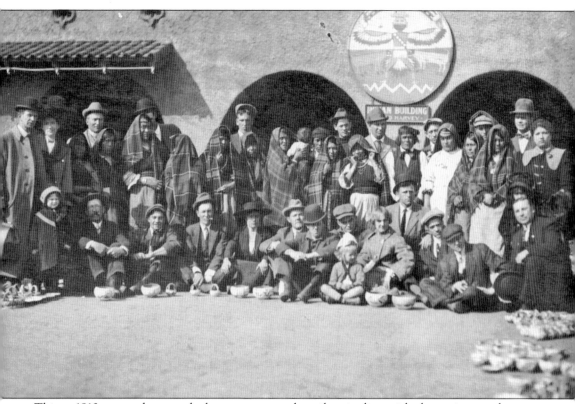

This *c.* 1910 group photograph shows passengers happily mingling with the native merchants and other employees of the Alvarado. For many Easterners, the Alvarado presented them with their first experience with Native Americans, and the travelers were immediately fascinated. Never a business to waste an opportunity for tourist dollars, the Fred Harvey Company had, by the mid-1920s, arranged for automobile tours to take travelers through some of the local pueblos. Couriers for the buses out of Albuquerque were, according to an interview with tour-director Erna Fergusson, "young women of education and some social grace, able to meet easily and well all kinds of people." These "Indian Detours" proved to be extremely popular. (Courtesy Nancy Tucker.)

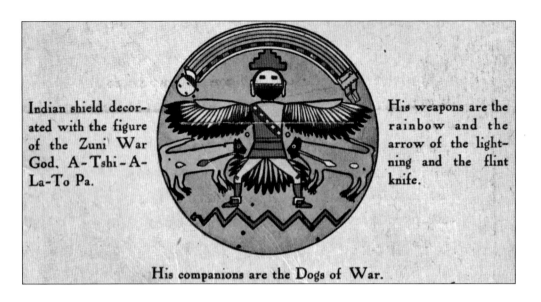

Indian shield decorated with the figure of the Zuni War God. A-Tshi-A-La-To Pa.

His weapons are the rainbow and the arrow of the lightning and the flint knife.

His companions are the Dogs of War.

This illustration from a package of Harvey Hotel postcards features a depiction and explanation of the shield emblazoned upon the Alvarado's Indian Building. The Indian Building was, in many ways, the centerpiece of the Alvarado complex, a museum and gallery where tourists could steep themselves in the romance of Native American cultures and then purchase a memento of their experience. The Fred Harvey Company had hired interior designer Mary J. Colter to appoint the hotel and the Indian Building in particular. Her work, which emphasized Southwest motifs (as shown in the c. 1910 postcard of the Indian Room pictured below), impressed the company so much that she eventually became one of their prized architects, designing several Harvey buildings, including Bright Angel Lodge and the Desert View Watchtower at the Grand Canyon. (Both courtesy Nancy Tucker.)

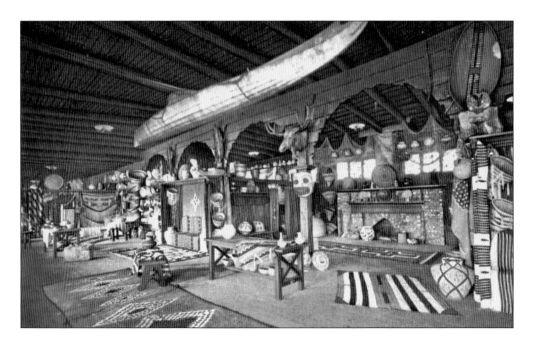

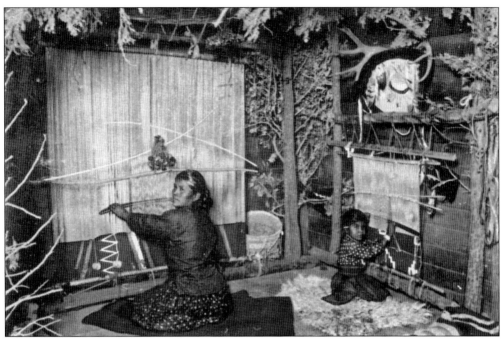

Visitors to the Alvarado complex were able to witness Native Americans at work producing the crafts available for sale, as seen in these two c. 1915 postcards. One of Fred Harvey's protégés, Herman Schweizer had operated a Harvey lunchroom in Coolidge, New Mexico, and had developed good relationships with artisans from the nearby Navajo Reservation. When the Fred Harvey Company decided to incorporate the sale and creation of Native American crafts into the Alvarado Hotel, Schweizer traveled throughout the Southwest seeking Navajo, Hopi, and Pueblo goods to sell in the Indian Building and artisans willing to travel to Albuquerque and work as a living display. (Both courtesy Nancy Tucker.)

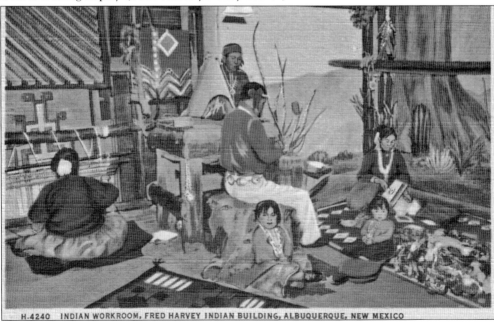

H-4240 INDIAN WORKROOM, FRED HARVEY INDIAN BUILDING, ALBUQUERQUE, NEW MEXICO

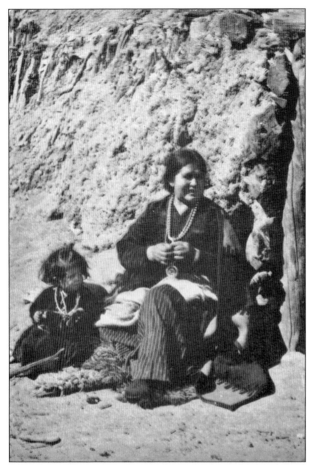

One of the Native American employees of the Indian Building was Elle of Ganado (pictured at left), a Navajo weaver renowned for her skill. In 1903, Albuquerque's Commercial Club chose Elle to weave a blanket for the soon-to-visit U.S. president Theodore Roosevelt. Unfortunately, rather than allow the artisan to present her own creation, the Commercial Club provided the (rather artless) design for her: a woven rendition of the club's membership card. (Courtesy Nancy Tucker.)

For the proprietors of the Indian Building, literally no aspect of Native American culture was sacred. As this c. 1910 postcard of a "Hopi altar" in the Indian Room shows, Native American religion was just one more attraction to draw in tourists. Sadly, this attitude proved all too pervasive. (Courtesy Nancy Tucker.)

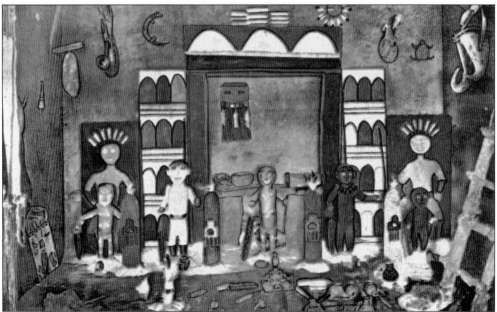

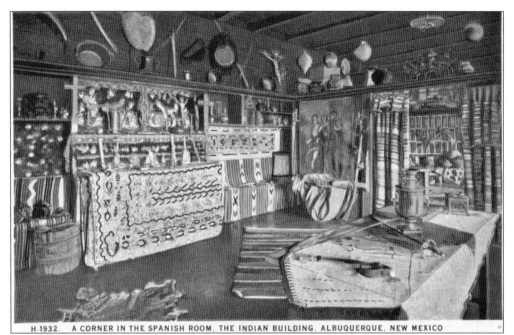

H-1932. A CORNER IN THE SPANISH ROOM, THE INDIAN BUILDING, ALBUQUERQUE, NEW MEXICO

With Native Americans successfully marketed in the Indian Room, the Fred Harvey Company next added a "Spanish Room" (shown in the c. 1910 postcard above) to showcase New Mexican Hispanic culture. Like the Indian Room, the Spanish Room featured an informational exhibit and a variety of crafts for sale. The Spanish Room seems to have been less popular than the Indian Room, and there is no mention of Hispanic artisans working on the premises. (Courtesy Nancy Tucker.)

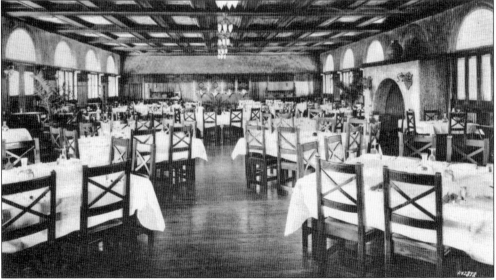

The Fred Harvey Company had begun with two railroad cafés in Kansas and Colorado, and good food remained a core feature of the enterprise. This early-1900s postcard shows the Alvarado's dining hall as spacious and inviting, an undoubtedly welcome rest for weary rail travelers. The hotel's dining complex also featured its own butcher shop and a cutting-edge refrigeration room. (Courtesy Nancy Tucker.)

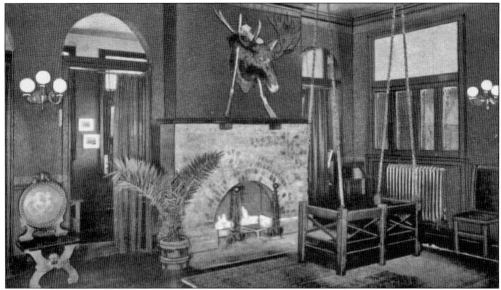

This postcard of a quiet fireside corner shows the general Western theme and Southwest accents of the hotel's lobby. The interior decorations of Mary J. Colter and others allowed guests from Eastern metropolises to feel as though they were experiencing something of the "wild" West, even as they dined and slept in luxury. In the age of the railroad, the Alvarado was a prestigious focal point for New Town Albuquerque's social life, with many events taking place in its grand dining hall and arcaded courtyards. However, as the railroad's importance faded, the Alvarado faded along with it, becoming little more than a flophouse in its final years. The 1925 photograph below gives us one last glimpse of the hotel's golden age, showing the excitement surrounding a visit from silent film actor (and Charlie Chaplin costar) Jackie Coogan, an event that featured the 11-year-old participating in a Navajo ceremony. (Above courtesy Nancy Tucker; below courtesy CSR William A. Keleher Collection 000-742-0234.)

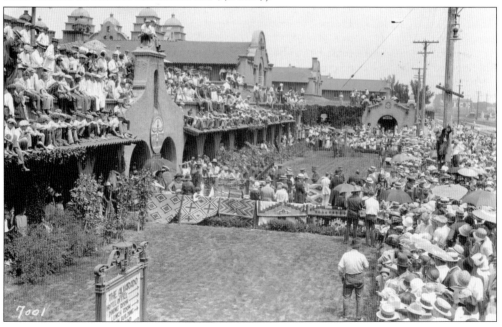

Six

THE RISE OF NEW TOWN

Suddenly, there were two Albuquerques. The Villa de Alburquerque, after a half-century of dramatic change, was now outflanked by the rapidly growing town beside the AT&SF depot. As more and more businesses flocked to the newly platted area east of the villa, residents began to refer to the area as "New Town Albuquerque" and derisively called the villa "Old Town."

The army post had dissolved in 1867, and as businesses headed east, economic opportunities in Old Town Alburquerque became fewer and fewer. No longer was it a thriving city center, noisy with the sounds of commerce and the bustle of visitors and new arrivals. With the fateful decision to locate the railroad nearly two miles away from the plaza, Old Town was cut off, set adrift by the very city it had helped to create. In a final insult, when New Town Albuquerque incorporated in 1891, Old Town was left outside the city limits. By the 1920s, when New Town Albuquerque's rapid growth caused it to absorb its birthplace and namesake, many of Old Town's buildings were abandoned and crumbling.

Meanwhile, New Town Albuquerque buzzed with excitement. Hotels in frame buildings rose up to house rail passengers, warehouses and industrial lots clustered beside the railroad itself, and saloons and restaurants lined its east-west thoroughfare, Railroad Avenue. Horse-drawn streetcars intermittently ferried passengers along the avenue, when their operators weren't pausing for a drink at one of the local bars. It was, in short, an exciting and chaotic place.

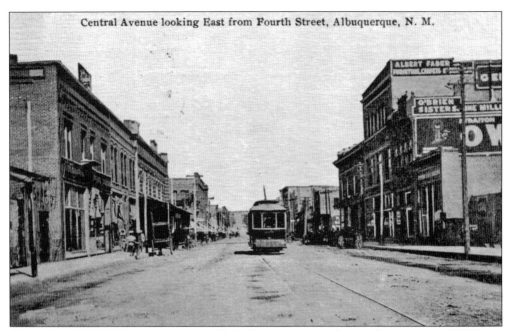

Central Avenue looking East from Fourth Street, Albuquerque, N. M.

Present-day Central Avenue was originally little more than a dirt track connecting Old Town Albuquerque to the railroad depot two miles away. Sensibly enough, it was named Railroad Avenue until 1907. As New Town grew, most buildings sprang up within a few blocks of this east-west artery. This 1911 postcard shows the heart of the bustling burg and one of the horse-drawn streetcars that connected New Town to Old Town. (Courtesy Nancy Tucker.)

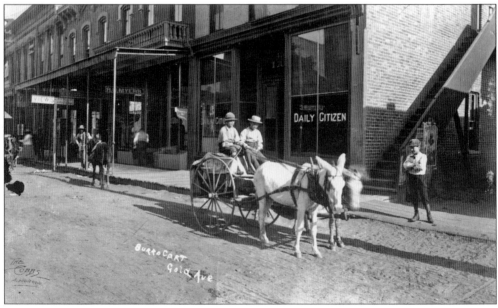

Walter G. Marmon, an Ohio civil engineer, was given the task of surveying the New Town site and naming its streets. Gold Avenue, shown here in this 1900s photograph, is one of several streets he named for minerals occurring in New Mexico, including Silver, Copper, Lead, Coal, and Iron Avenues. (Courtesy CSR William A. Keleher Collection 000-742-0546.)

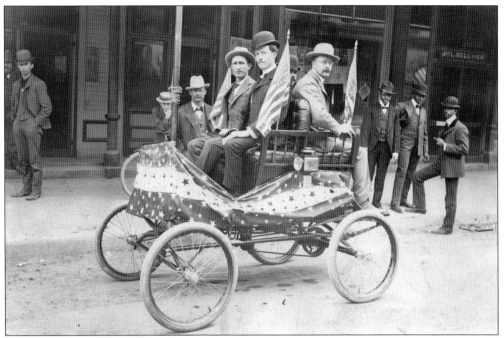

In 1897, New Town welcomed its first automobile, owned by bicycle merchant J. L. Dodson (pictured here, far left of the passengers). It was a steam-driven Locomobile, and despite only being able to travel 20 miles before the water tank needed to be refilled, Dodson had driven it south from Colorado over the forbidding Raton Pass. (Courtesy CSR PICT 000-119-0747.)

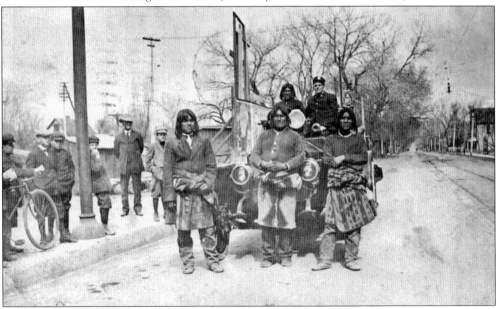

Automobiles proved a boon to the Albuquerque Fire Department (shown posing with Native Americans in this c. 1910 photograph). As many of New Town's buildings were constructed with wooden frames and other flammable material, an efficient fire department was necessary for the survival of the town. A bell hung from a derrick on First Street and Railroad Avenue to alert townsfolk of fire and other emergencies. (Courtesy Nancy Tucker.)

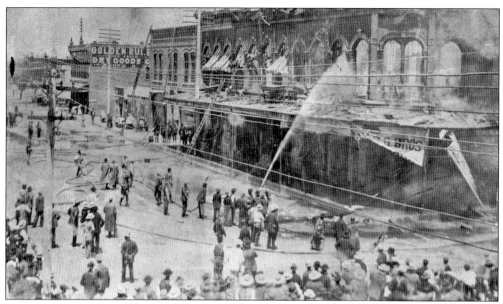

One of the many New Town buildings to fall to fire was the Grant Opera House, shown here during its 1899 blaze. The Opera House, which stood at the corner of Third Street and Railroad Avenue, was built by Angus A. Grant, a contractor with the AT&SF Railroad Company. Grant also established a construction camp that formed the kernel of the town that would later bear his name: Grants, New Mexico. (Courtesy CSR PICT 000-119-1745.)

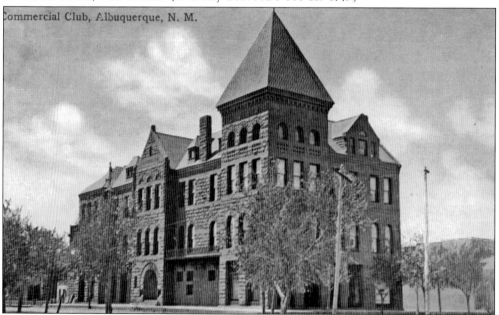

The Albuquerque's Commercial Club's members, tireless boosters for the city, erected a new building for themselves in 1892 at the corner of Fourth Street and Gold Avenue. The club occupied the upper stories, while an undertaker operated on the ground floor. From 1922 to 1935, the undertaker was Chester French, founder of longtime Albuquerque institution French Mortuary. Although the building was demolished in 1954, red sandstone bricks from the structure were incorporated into the Simms Building, one of Alburquerque's first skyscrapers. (Courtesy Nancy Tucker.)

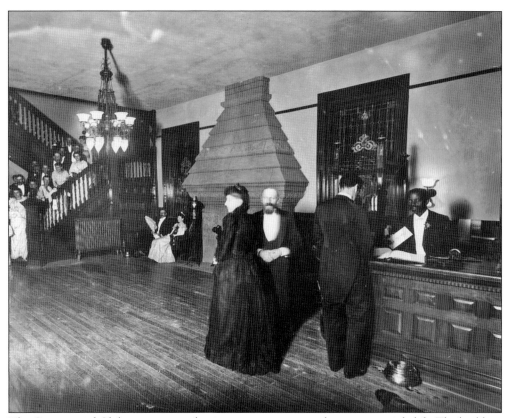

The Commercial Club was one part business organization and one part social club. The building contained a ballroom, billiard hall, library, saloon, and even sleeping quarters. This photograph, from the club's opening gala in 1892, shows Henry M. Jaffa, Albuquerque's first mayor, and his wife (center) enjoying the festivities. (Courtesy CSR PICT 000-119-0762.)

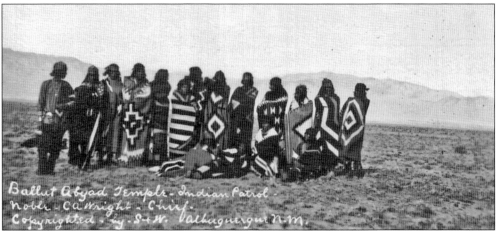

Many of New Town Albuquerque's community leaders were involved in another primarily social organization. The Ballut Abyad branch of the Ancient Arabic Order of the Nobles of the Mystic Shrine (colloquially known as the "Shriners") was active in New Town from an early date. This photograph shows members of the "Indian Patrol," none of whom actually were Native American. (Courtesy Nancy Tucker.)

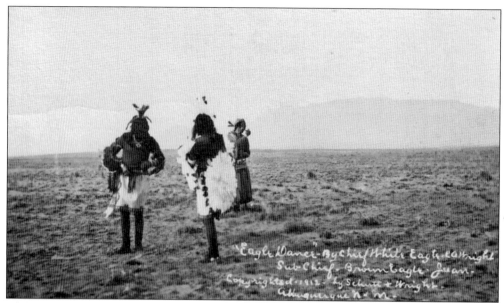

The white arrivals in the Southwest have always had a complicated relationship with their Native American neighbors. On the one hand, there has historically been considerable friction between the groups over land and natural resources. On the other, there is a seemingly surprising tendency toward emulation. This 1900s photograph shows white members of the Shriner's Indian Patrol engaged in an "Eagle Dance." (Courtesy Nancy Tucker.)

This 1908 real-photo postcard shows an ugly aspect of white views of Native Americans. "These are a couple of Indians Jim swapped [with] last Sunday," the author states. "They don't look very much like men, do they?" Sadly, this xenophobic attitude was all too common for many years. It is worth noting that New Mexico did not grant Native Americans the right to vote until 1962. (Courtesy Nancy Tucker.)

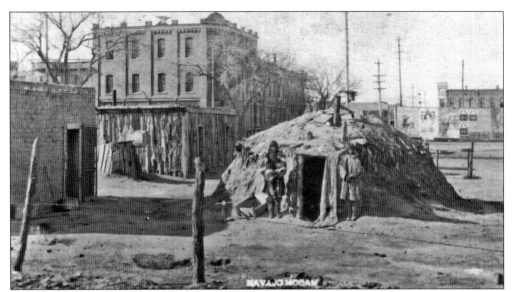

Native Americans in New Town Albuquerque were often hired for their exotic appeal in much the same way as at the Alvarado Hotel. This early-1900s real-photo postcard shows two Native American men "guarding" the entrance to a replica Navajo hogan. The hogan was, in fact, a curio store and craft gallery. (Courtesy Nancy Tucker.)

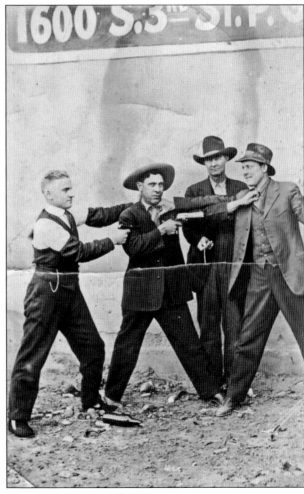

How many Easterners stepped off of the train and into the dusty streets of New Town with their heads full of tales of the "Wild West" as related by dime novels? Nascent photography studios seemed to have been kept in brisk trade by groups of men who wished to pose as gunfighters and cowboys, as in this 1905 real-photo postcard. (Courtesy Nancy Tucker.)

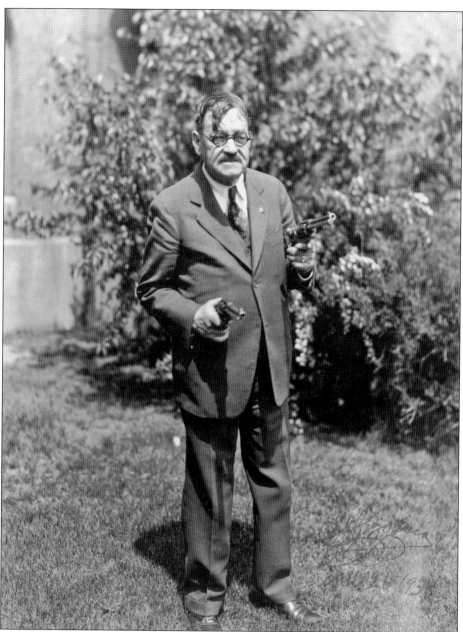

Meanwhile, authentic legends walked the streets of Albuquerque. Elfego Baca, posing in this 1932 photograph, was one such famous figure who settled in town. Baca had served as sheriff in Socorro County during the late 1800s and had numerous tales ascribed to him. The most famous of these recounted how he withstood a siege by 80 murderous cowboys. Baca, the sole defender, had retreated into an adobe shack and managed to hold off the attack for some 36 hours. Supposedly, the cowboys fired some 4,000 bullets into the shelter, but every one miraculously missed the lawman, while Baca managed to kill four of his attackers. When the cowboys left to acquire more ammunition, Baca walked out of the shack, unharmed. While in Albuquerque, Baca worked as an attorney and served as the U.S. representative for reviled Mexican president Victoriano Huerta. (Courtesy CSR William A. Keleher Collection 000-742-0006.)

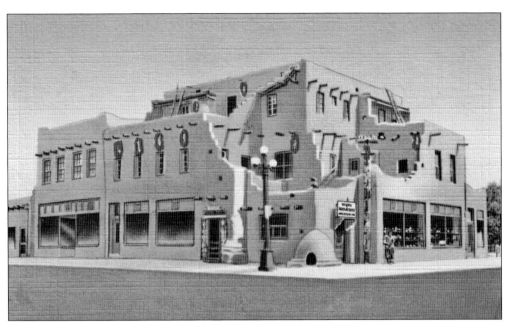

A few of the businesses started in New Town Albuquerque have managed to survive into the present day. One such institution is Wright's Trading Post, which opened in 1907 on Central Avenue. Charles Wright, the original owner, had worked in the Indian Room at the Alvarado Hotel and saw the tremendous financial opportunity in selling Native American crafts. The Trading Post, specializing in Navajo and Pueblo crafts, was immediately successful. Wright was soon able to construct a building of his own design at the corner of Fourth Street and Gold Avenue, a striking, multistoried pueblo in the heart of New Town (pictured above on a 1938 postcard). To attract customers, Wright hired Native Americans to welcome tourists (such as those shown at right in a 1920s postcard), including a Navajo holy man who performed rituals for onlookers. (Both courtesy Nancy Tucker.)

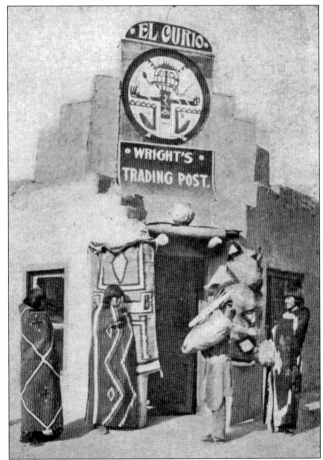

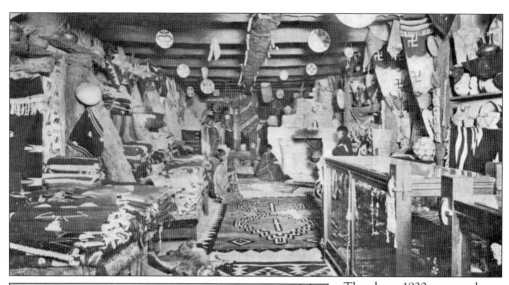

$100 REWARD

AUGUST 1st, 1923

For the recovery of goods, and the arrest and conviction of the parties who broke into Wright's Trading Post, in Albuquerque, N. M., early Tuesday morning, July 31, 1923, and secured the following list of gold and silver jewelry, Indian and Mexican, and other goods.

225 solid gold rings set with different gems; 12 gold wedding rings; 36 gold filigree rings set with gems; 1 man's Masonic ring, very large, with one diamond and pear shaped ruby; 2 gold filigree brooches set with cameos; 50 emblematic lapel buttons; 2 gold filigree Shrine lapel buttons set with stone; 1 gold filigree necklace with lavaliere with eleven to fifteen turquoises set in; 1 gold filigree butterfly with turquoise sets in wing; 1 lot of gold filigree pendants, brooches, set and unset; 1 heavy chain with large lavaliere of gold filigree set with large black opal; 15 gold chains and lavaliere; 1 diamond ring; 1 opal with several diamonds around; 1 lot of silver rings with different stones; 1 lot of scarf pins set with stones; 15 silver lavalieres and chains; 8 dozen leather banners, about 6x8 inches, burned "Wright's Trading Post," also Wright building on, also "Mother," "Perfect Day" and "Where the West Begins;" 1 lot of pillow covers of satin with the above mottoes on; 100 pieces of Mexican laces and drawn work; cowboy chaps; Indian suits; several Navajo rugs and blankets; 1 9-M Lugar revolver with 150 shells; 1 lot of Navajo jewelry—bracelets, rings, necklaces and earrings; 15 silver necklaces set with gems.

Keep sharp lookout for parties trying to dispose of the above list of goods, and wire all information to me at my expense.

WRIGHT'S TRADING POST

Charles A. Wright, Prop.
Albuquerque, N. M.

VALLIANT PRINTING CO., ALBUQUERQUE, N. M.

The above 1920s postcard shows the interior of Wright's store absolutely stuffed with Native American–made goods. The rafters visible in the photograph are pine *vigas* from the Zuni Mountains (presumably processed by the American Lumber Company); not visible is a 10-foot adobe fireplace that warmed visitors in Albuquerque's chill winter. After a 1923 robbery of the store, the wanted poster shown at left was posted all over town. It gives some idea of the variety of merchandise available (from gold filigree butterflies to cowboy chaps and "Indian suits"). Amazingly, the business has survived into the present day and recently celebrated its 100th anniversary. (Above courtesy Nancy Tucker; left courtesy CSR New Mexico History Collection MSS 349 BC.)

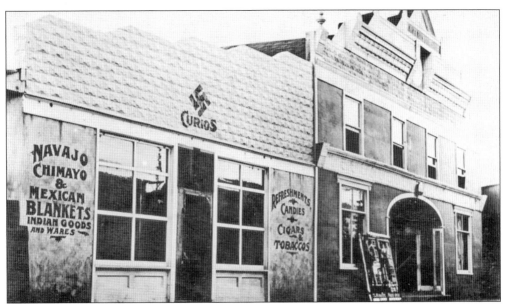

Native American crafts were big business in New Town, and it seemed like every shop offered some variety of blankets, pottery, or jewelry for sale. Note the swastika emblazoned on the shop's front in this 1920s photograph. The symbol had been used by Native American peoples for generations before its unhappy 20th-century associations and is a common motif in New Mexican art. (Courtesy Nancy Tucker.)

Baseball was a fixture in Albuquerque from an early date. In 1890, W. T. McCreight (a former professional player) organized Albuquerque's first baseball club (shown at right in 1894), which was called the Browns after his former team. Because the Browns played after the traditional baseball season ended, McCreight was able to recruit pros from the East, and the team handily beat their Southwestern competition. (Courtesy CSR William A. Keleher Collection 000-742-0210.)

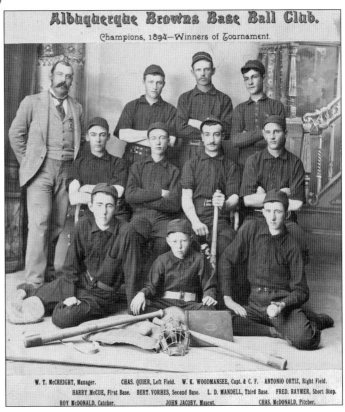

Albuquerque Browns Base Ball Club.
Champions, 1894—Winners of Tournament.

W. T. McCREIGHT, Manager. CHAS. QUIER, Left Field. W. K. WOODMANSEE, Capt. & C. F. ANTONIO ORTIZ, Right Field.

HARRY McCUE, First Base. BERT. VORHES, Second Base. L. D. MANDELL, Third Base. FRED. RAYMER, Short Stop.

ROY McDONALD, Catcher. JOHN JACOBY, Mascot. CHAS. McDONALD, Pitcher.

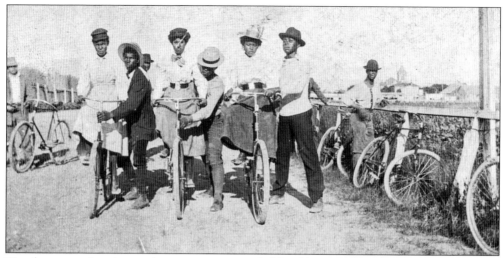

Bicycles were a hugely popular recreation in early New Town. Before the automobile became widely available, bicycles were a widespread form of transportation. Adults commuted to work, boys scavenged discarded frames to turn into usable transport, and cycle races down Albuquerque's dusty dirt roads and into the mountains were a major sporting event. This 1900s photograph shows three couples enjoying a social ride. (Courtesy CSR William A. Keleher Collection 000-742-0263.)

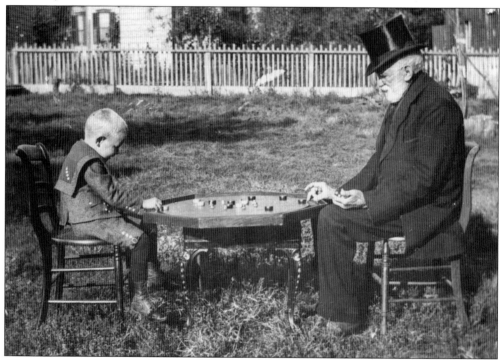

Albuquerqueans also enjoyed more staid leisure activities. In this photograph, Sen. George Coffin of Kansas enjoys a game of Krokinole with his grandson, Percy Gillette Cornish Jr., while on a visit to New Town in 1900. Young Percy would become one of Albuquerque's three generations of physicians from the Cornish family, following in his father's footsteps and raising his own son to follow in his. (Courtesy CSR PICT 000-119-0358.)

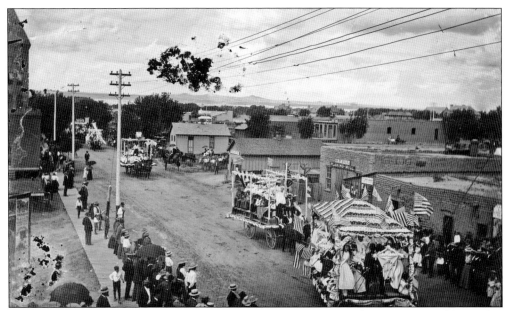

The primarily white and English-speaking residents of New Town kept a continual hope that New Mexico would be admitted as a state and held Territorial Fairs yearly. This photograph from the 1892 Territorial Fair shows a parade of flag-and-bunting-wrapped floats traversing Railroad Avenue. It would be two decades before the residents' hopes for statehood were realized. (Courtesy CSR PICT 000-119-0722.)

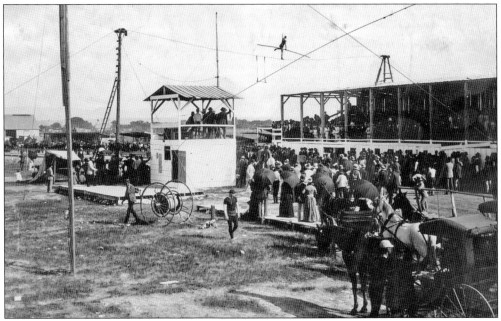

The fair featured many varieties of entertainment for residents of New and Old Albuquerque. In this 1892 photograph, a circus performs for the gathered crowd at the fairgrounds near Old Town. Other events included demonstrations by the U.S. Cavalry, exhibition games by the Albuquerque Browns, and horse-and-buggy races around the fairgrounds' track. (Courtesy CSR PICT 000-119-0729.)

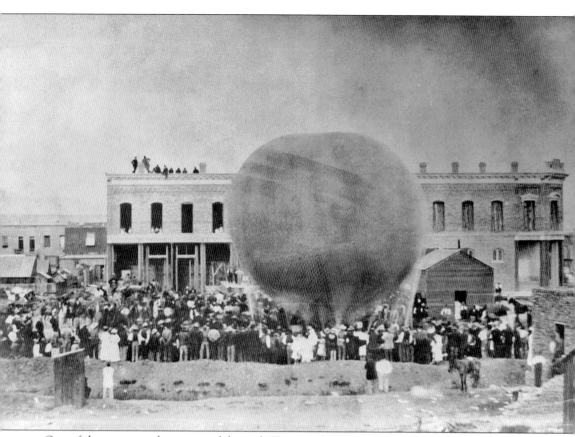

One of the most popular events of the early Territorial Fair would later become an integral part of Albuquerque's modern identity. During the fair of 1882, Albuquerque's first balloon ascension lifted off, with local barkeep "Professor" Park Van Tassel at the helm, before a crowd of excited onlookers. The balloon, named "the City of Albuquerque," took over 24 hours to fill with coal gas and proved to be an erratic transport. Although Van Tassel reached a height of 14,000 feet quite easily, the return trip was altogether too rapid, and the "Professor" was forced to discard his lunch and overcoat in a desperate bid to slow his descent. This photograph of the balloon's imminent liftoff captures the excitement of that day. (Courtesy CSR PICT 000-119-0743.)

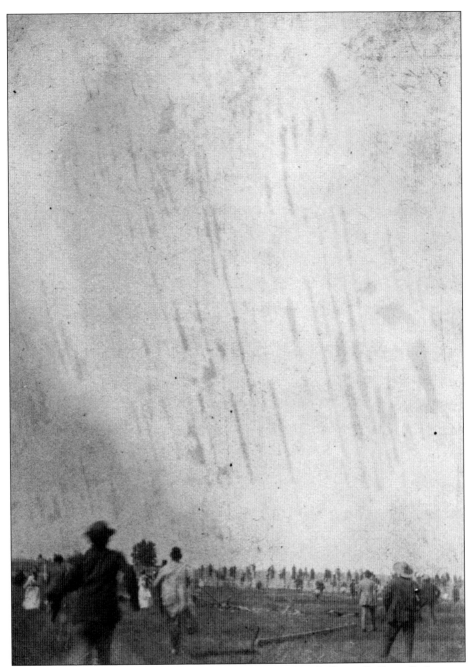

Here Van Tassel's earthbound audience chases the ascending balloon. Balloon flights were an integral part of the Territorial Fair for many years. Other memorable ascensions included that of Roy Stamm, a local fruit wholesaler, who first flew during the 1907 fair. Stamm's experience proved to be more exciting than Van Tassel's: frightened valley residents supposedly took up rifles and shot some half-dozen times as the hydrogen-filled balloon flew overhead. Later fairs featured airplanes and famous aviators in addition to balloons. Sadly, a scheduled appearance by Charles J. Stroebel and his bicycle-powered dirigible in 1909 had to be cancelled after Stroebel wrecked his craft. (Courtesy CSR PICT 000-119-1744.)

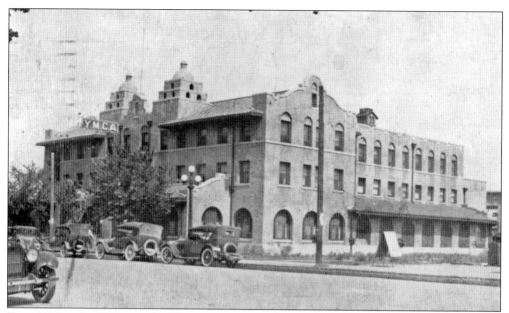

From 1890 to the 1930s, new buildings were constantly going up in New Town Albuquerque. This *c.* 1920 photograph shows the New Town YMCA building, constructed in 1915. It was a beautiful example of the Mission Revival style. Like so many of New Town's unique buildings, the YMCA building was demolished during downtown's urban renewal phase. (Courtesy Nancy Tucker.)

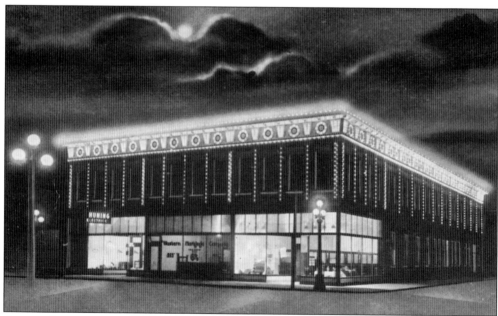

A natural gas generating plant on Railroad Avenue and Broadway lit New Town Albuquerque as early as 1898. Electricity soon followed. The Albuquerque Gas and Electric building at the corner of Fifth Street and Central Avenue, pictured in a 1925 postcard, was completed in 1915 and advertised its business with a dazzling encrustation of lights. The building remains, as do its multitude of now-darkened light sockets. (Courtesy Nancy Tucker.)

New Town's post office at the corner of Fourth Street and Gold Avenue (pictured above around 1915) was completed in 1908. It originally housed several other federal agencies but quickly became overcrowded, necessitating the construction of a federal building next door. The post office utilized the building until 1972, before moving into the Dennis Chavez Memorial Building. The old post office is Albuquerque's oldest federal building and currently houses a charter high school. (Courtesy Nancy Tucker.)

Even as New Town was coming into its own, the cornerstone for Albuquerque's next phase of development was beginning to rise in the sand hills to the east. In 1889, Gov. Edmund G. Ross signed a bill designating Albuquerque as the site of the state's university (a maneuver that rankled Santa Fe politicos). This photograph from the early 1890s shows the initially remote location of the University of New Mexico (UNM). (Courtesy Nancy Tucker.)

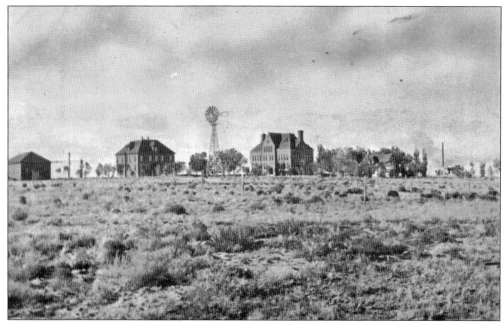

A handful of Victorian buildings connected to New Town by the rugged Railroad Avenue (now Central Avenue), the university was hardly an impressive site at its birth. Pictured in this late-19th-century postcard is UNM's first building, Hodgin Hall (to the right of the windmill). In its first year, UNM served 108 students. (Courtesy Nancy Tucker.)

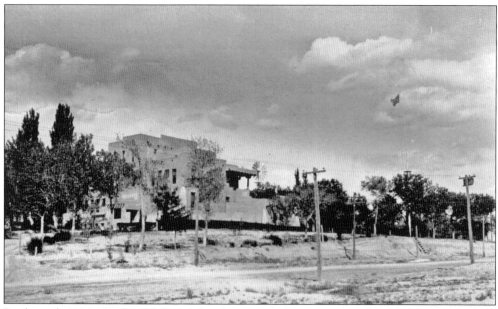

By the early 1900s, Hodgin Hall was already in need of serious repairs. UNM president William Tight used the opportunity to completely remodel the building in an early example of the Pueblo Revival architectural style. Pictured here in this c. 1910 postcard is Hodgin Hall as it appeared shortly after its remodeling. (Courtesy Nancy Tucker.)

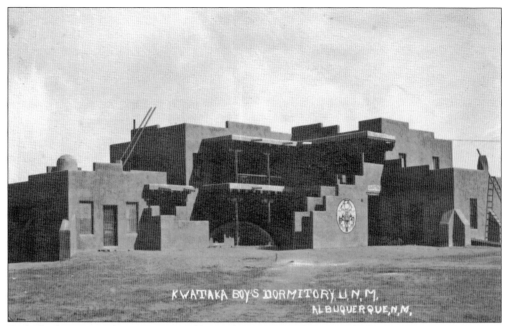

Tight had a vision of UNM as a "Pueblo on the Mesa," and most of the buildings completed under his tenure reflected this. Pictured here is Kwataka Hall, one of the university's first dormitories. Both it and its sister building, Hokona Hall, were designed by architect E. B. Cristy. (Courtesy Nancy Tucker.)

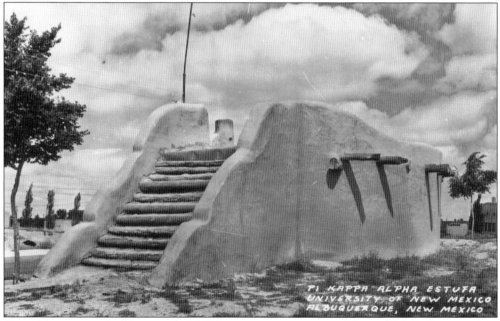

One of the strangest buildings on the UNM campus is one contracted during Tight's administration. The Estufa (pictured about 1915), modeled on the ceremonial *kiva* used by the Pueblo peoples, is a squat building lacking any windows or doors, apart from a rooftop entrance. It was originally built for members of the Tri Alpha Fraternity, which later became the Pi Kappa Alphas. The organization still holds chapter meetings inside. (Courtesy Nancy Tucker.)

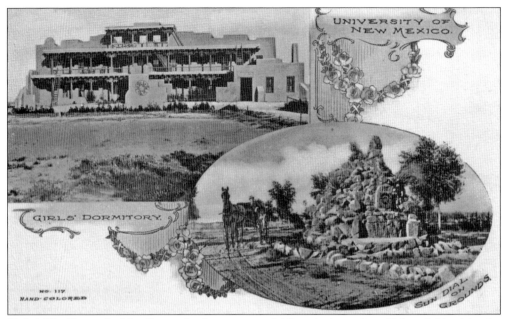

Tight's "Pueblo on the Mesa" proved to be controversial from its inception. Although his vision for the institution would dictate the look of UNM to the present day, many political contemporaries found the Pueblo Revival style to be an eyesore and bitterly complained about it. In fact, this controversy was responsible in large part for Tight's early dismissal from the UNM presidency. Pictured above on this early-1900s postcard is Kwataka's sister dormitory, Hokona Hall, and a sundial/bench presented as a gift by the class of 1907. Despite the controversy, UNM students were evidently proud enough of their institution to decorate one of the Sandias foothills with a white letter "U," as shown below in a *c.* 1930 postcard. Years later, however, UNM's ecologically minded engineering students would remove the stones and allow the hill to stand unmarked. (Both courtesy Nancy Tucker.)

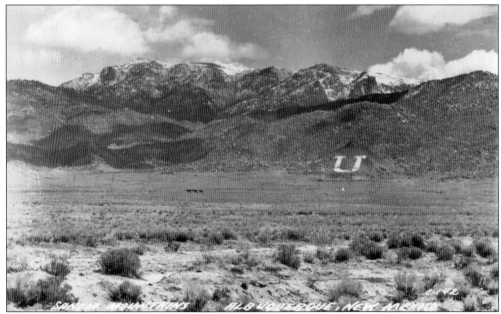

Seven

THE HEART OF
THE WELL COUNTRY

They called it "the White Plague," and in 1913, fifty percent of Albuquerque's population either had it or shared their household with someone who did. Ninety percent of those sufferers were born in other states and had fled west at the instruction of their doctors, and the city's population was exploding as a result. Central Avenue, which had begun life as Railroad Avenue and would later enter its golden age as U.S. Route 66, was now granted another name by a wryly macabre populace: Tuberculosis Avenue, for the sanatoriums lining it that were rapidly coming to define the city in the eyes of the world.

For more than a century, the tuberculosis epidemic had ravaged American and European society. The disease spread quickly and mysteriously, its symptoms (bloody cough, fever, chills, and a rapidly wasting physique) debilitating, lingering, and almost always fatal. The science of the day had yet to find a cure and instead grasped at straws: in desperation, doctors prescribed thrice daily bleedings, marathon horseback rides, and myriad other red herring "treatments" that did little beside distract the patient. In the late 1800s, cause and cure were linked to climate; the humid, hot airs of sea level environs were blamed for its spread; the exotic, high mountain deserts of the Southwest were looked to for salvation. "Go west" were the doctors' orders.

For many, "west" meant New Mexico and, quite often, Albuquerque.

"Without exception Albuquerque has the finest climate the year around to be found in the United States. New Mexico is the world's sanitarium for consumptives and Albuquerque . . . is the driest and most healthful spot in the Territory," ran the patter in *Albuquerque, New Mexico's Chief City of a New Empire of the Great Southwest*, a 1908 brochure printed to feed the city's emerging industries.

They came in droves. The Albuquerque population exploded, and although no specific records were kept on the number of tuberculosis patients who arrived from the East, contemporary reports speak of them in "thousands" and "multitudes." Many would die, some would recover, but all would play a hand in creating Albuquerque.

MOUTH AND THROAT INSTRUMENTS.

The ravages of tuberculosis (TB) became an industry unto itself, with a multitude of snake-oil "cures" sold throughout the 19th and early 20th centuries. This late-1800s advertisement depicts a device to pump medicine into the consumptive's lungs. It is doubtful this did anything other than cause discomfort. (Courtesy author's collection.)

The precepts of climatology held that dry, cool air was necessary to fight tubercular infection, and communities throughout the Southwest sought to show that their air was the coolest and driest. City boosters, such as the Albuquerque Commercial Club, saw tuberculosis as a potential boon for their growing city and sought to attract ailing, and wealthy, Easterners with hyperbolic claims such as those from this 1920s-era advertisement. (Courtesy Albuquerque Public Library Special Collections.)

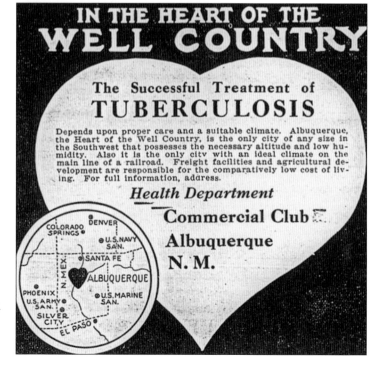

IN THE HEART OF THE WELL COUNTRY

The Successful Treatment of TUBERCULOSIS

Depends upon proper care and a suitable climate. Albuquerque, the Heart of the Well Country, is the only city of any size in the Southwest that possesses the necessary altitude and low humidity. Also it is the only city with an ideal climate on the main line of a railroad. Freight facilities and agricultural development are responsible for the comparatively low cost of living. For full information, address.

Health Department

Commercial Club Albuquerque N. M.

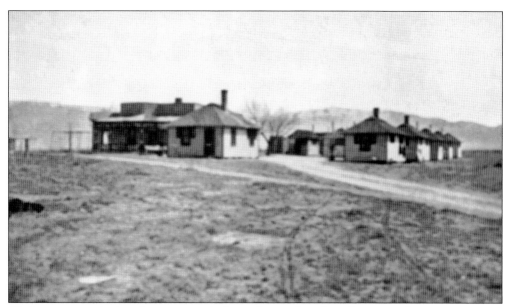

Their strategy worked, and soon sanatoria (group homes for tubercular patients) were springing up in the sand hills around New Town. This 1912 photograph shows the original site for Methodist Deaconess Sanatorium. Relatively healthy patients were housed in the small cabins, where they slept with their windows open in order to fully benefit from the supposedly healing air. (Courtesy author's collection.)

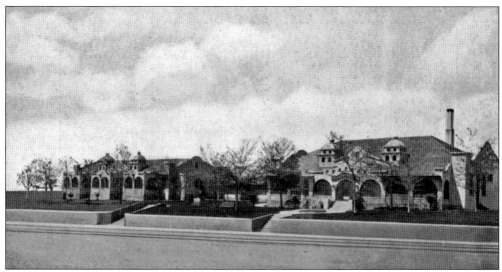

Methodist Deaconess was one of the most successful of the sanatoria, eventually expanding to take over the facilities of other, less profitable institutions and opening rustic health camps in the Sandia Mountains. This c. 1916 photograph shows the growing sanatorium's Mission Revival style at its later location, just west of the University of New Mexico on Central Avenue. (Courtesy author's collection.)

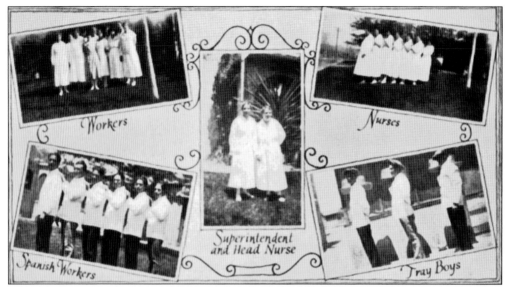

The sanatoria, which attracted a wealthy class of Easterners to the city, soon became one of Albuquerque's largest employers. Many of the hospitals prided themselves on the luxury they provided for their patients, advertising, as in this c. 1916 promotional photograph for Methodist Deaconess, their large staff outfitted like servants at a fine hotel. (Courtesy author's collection.)

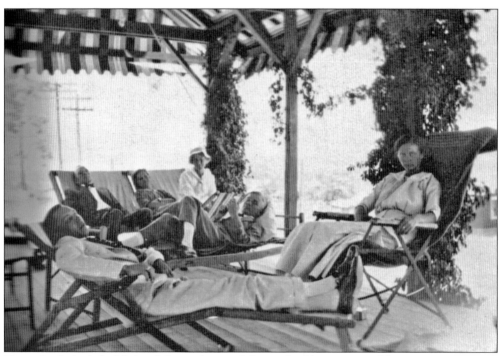

Due to both the beliefs behind climatology and the medical limitations of the time, recuperating in the Southwestern climate mainly consisted of getting plenty of rest. Patients spent their days reclined in chaise lounge chairs, as depicted here in this 1917 photograph. The ubiquitous use of the chaise lounge gave rise to a popular bit of word play: TB patients were said to be "chasing the cure." (Courtesy Albuquerque Public Library Special Collections.)

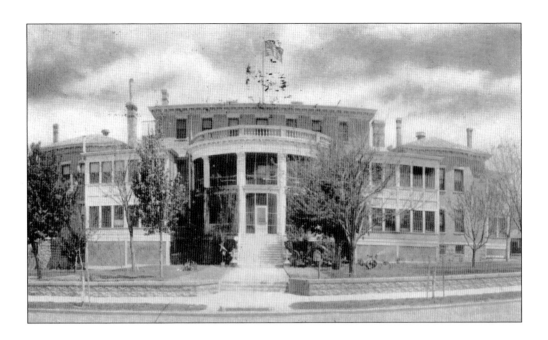

St. Joseph's Sanatorium, pictured above in this *c.* 1910 postcard, was the first tuberculosis treatment facility in Albuquerque. It opened in 1902 and quickly became one of Albuquerque's most successful "sans." Like most of the sanatoriums, St. Joseph's became a self-contained city unto itself. In the postcard below, the infrastructure of the facility is evident, with a heating plant (attached to the tall smokestack), telegraph lines, and its own water tower visible. Heating was particularly important for the facilities because residents were encouraged to sleep with their windows open, even during the winter. (Both courtesy Nancy Tucker.)

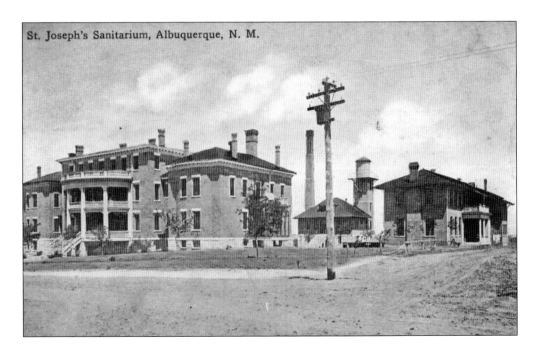

St. Joseph's Sanitarium, Albuquerque, N. M.

This early-1900s photograph shows a corner of the lobby at St. Joseph's. Patients with enough energy were encouraged to participate in various low-key leisure activities, such as knitting, playing musical instruments, or even putting on plays. However, if their disease advanced to a sufficient degree, it was likely the doctors would rule out any activity at all, scolding such a patient for even reading a book. (Courtesy CSR 000-010-0021, Felipe Chavez Memorial Collection.)

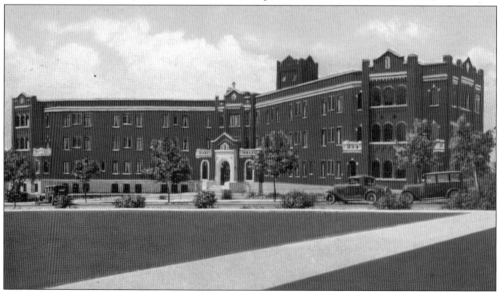

Like Methodist Deaconess, St. Joseph's success soon translated into expansion and remodeling. This 1930s postcard shows St. Joseph's newly built facilities. Once effective antibiotic treatments for tuberculosis became widely available, most Albuquerque sanatoriums shut down. St. Joseph's, however, had become integral to the medical community and survived until it was bought out in the late 20th century. (Courtesy Nancy Tucker.)

By 1910, Albuquerque had a population of 13,000 people, 3,000 of whom were tuberculosis patients. Naturally, this led to a sudden, explosive need for health workers to attend to the "lungers" (as patients were crudely referred to). To that end, St. Joseph's opened a nursing school of its own. In this photomontage from the school's 1921 yearbook, young nursing students frolic in various Albuquerque locales. (Courtesy Albuquerque Public Library Special Collections.)

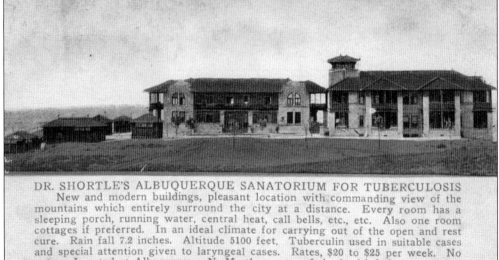

DR. SHORTLE'S ALBUQUERQUE SANATORIUM FOR TUBERCULOSIS
New and modern buildings, pleasant location with commanding view of the mountains which entirely surround the city at a distance. Every room has a sleeping porch, running water, central heat, call bells, etc., etc. Also one room cottages if preferred. In an ideal climate for carrying out of the open and rest cure. Rain fall 7.2 inches. Altitude 5100 feet. Tuberculin used in suitable cases and special attention given to laryngeal cases. Rates, $20 to $25 per week. No extras. Located at Albuquerque, N. M., the center of the health belt.
Dr. A. G. Shortle, Medical Director.
Dr. J. S. Cipes, Bacteriologist.
W. F. Johnson, Business Manager.

By the 1920s, sanatoriums were appearing everywhere. The sand hills east of New Town were particularly popular, with Shortle (pictured here in a 1920s postcard), Cipes, Hillcrest, Methodist, Albuquerque, and Presbyterian Sanatoriums all building facilities in the area. Most of the sans had one or more doctors in residence, a great boon to Albuquerque's medical community for decades to come. (Courtesy Nancy Tucker.)

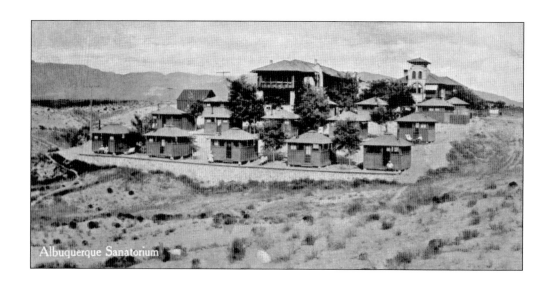

The cottages for recuperating consumptives, shown here surrounding Albuquerque Sanatorium in 1920, were designed more for quick construction and portability than for comfort. Usually quite small in size, they offered little more than a bed and perhaps a small kitchen area. The hope was that patients in the cottages (for instance, the unidentified gentleman in the *c.* 1920 photograph below) would soon be fully recovered and able to leave the sanatorium for good. The all-too-often realized fear was that their condition would worsen and they would need to be transferred to the central facilities. Some of the cottages were apparently quite sturdy and were used for cheap housing long after the tuberculosis era ended. A few may still be found around town to this day. (Both courtesy Nancy Tucker.)

According to North Valley resident Irene Fisher, by 1920, the sheer number of sick Easterners arriving in town gave rise to a peculiar expression: "you either came [to Albuquerque] for your health or for horse stealing." The multitudes of TB patients caused the sanatoriums' housing needs to skyrocket beyond their capabilities. As a result, many of the healthier patients found themselves set up in tents, causing the above advertiser (from an issue of the 1920s TB quarterly *The Herald of the Well Country*) to add a new demographic to their marketing strategy. Some sanatoriums founded rustic "health camps" in the Sandia Mountains, such as Methodist Deaconess's Camp Killgloom. At right is a sketch from the *Killgloom Gazette*, a hand-typed newsletter published by the Killgloom residents, depicting one of the lodgings at the camp in a none-too-favorable light. (Both courtesy Albuquerque Public Library Special Collections.)

TH E GAZETTE ART SUPPLEMENT.

MARCH 1914.

THE CRADLE OF FAME
THE BIRTHPLACE OF THE GAZETTE.

This comic strip originally appeared in the pages of a 1920s issue of the Albuquerque-published *The Herald of the Well Country.* Its depiction of a tuberculosis-infected man who accidentally causes the death of a young child through careless spitting speaks to the fears held by both noninfected townsfolk and the patients themselves. Many doctors wrote admonitions against spitting in particular, considering it one of the more efficient means of transferring the disease from one host to another. TB patients were given small cups to spit into, and an entire industry sprang up around their production. The fear of careless spitting also gave rise to the late-19th-century prevalence of the spittoon. (Courtesy Albuquerque Public Library Special Collections.)

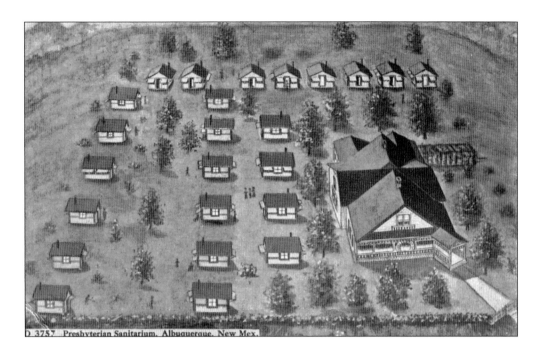

The humble facility depicted in the above 1902 postcard hardly seems like it would have made much of an impact on the growing city of Albuquerque. After all, it was but one of many sanatoriums of the day and a none-too-impressive one at first. Founded by a Reverend Dr. Cooper, himself a TB sufferer, Presbyterian Sanatorium was different from many of the others in that it treated patients regardless of their income or religious affiliation. Its first buildings were only a few small cottages erected on donated land, but within a few years, donations from Easterners had financed a major center (shown below around 1911) for the treatment of patients. Soon Presbyterian Sanatorium dominated Albuquerque's medical arena. (Above courtesy Nancy Tucker; below courtesy author's collection.)

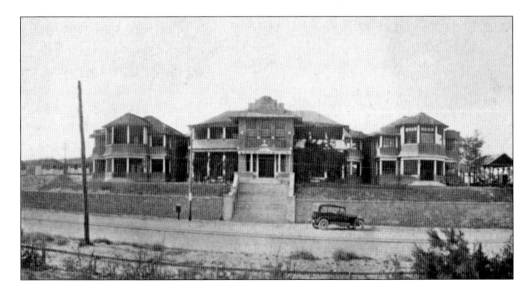

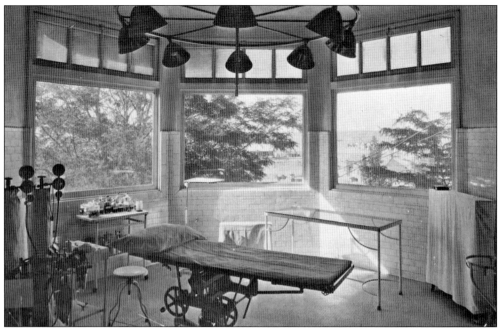

This 1920s photograph shows one of the operating rooms in the Presbyterian Sanatorium. The Presbyterian staff was apparently quite adept at fund-raising because donations to the facility provided state-of-the-art equipment and, in 1931, a cutting-edge research laboratory. Donations also helped the facility survive the Great Depression. Eventually, Presbyterian Sanatorium would become Presbyterian Hospital, which is today one of the largest medical facilities in the state. (Courtesy Albuquerque Public Library Special Collections.)

Of course, tuberculosis did not limit itself exclusively to the Easterners who arrived in Albuquerque. This photograph, taken in the 1930s, depicts the Albuquerque Indian Sanatorium, which treated Native American patients. It is one of the handful of sanatorium buildings that survived the near-eradication of tuberculosis and still serves as a hospital today. (Courtesy Albuquerque Museum, photograph by Brooks Studio, PA 1978-151-809.)

Eight

THE CITY IN STATEHOOD

Statehood had been a beguiling prospect for the New Mexico territory since Kearny first marched his army into Las Vegas, New Mexico, and declared it a part of the United States. Albuquerque, with its burgeoning population of English-speaking Easterners and its various thriving industries, perhaps wanted it more than most and had early on begun petitioning any government official who would hear it. To that end, members of the Albuquerque Commercial Club had been organizing Territorial Fairs, irrigation conferences, and agricultural expositions since 1881 in order to promote the territory and the city outside of its borders.

But it was not to be so easy. Even as California, Colorado, and Nevada, its sister territories from the Treaty of Guadalupe Hidalgo, sought and gained admittance, New Mexico's statehood was continually pushed back, year after year. There were many reasons for this. One was the U.S. Congress's outright xenophobic fear of the largely Spanish-speaking population and their deep-rooted culture. Another was a more overtly political reason. A *New York Times* article from 1893 spells it out: "New Mexico has Republican tendencies, and the Democrats in Congress do not care to take any action which may affect either the Senate or the House."

And so New Mexico waited.

The first U.S. president to visit Albuquerque was Theodore Roosevelt. Roosevelt arrived in May 1903 and gave several speeches, including one from a platform beside the Alvarado. Because of his known views in favor of Western expansion (which were racially based), many in Albuquerque hoped his administration would accept New Mexico as a state. This photograph of Roosevelt speaking in Robinson Park is from a later visit in 1912. (Courtesy Nancy Tucker.)

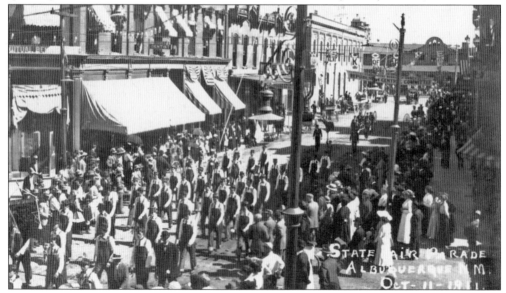

Roosevelt's tenure did not see New Mexico's entrance to the Union, however. That duty would fall to a notably less popular president's administration, that of William Howard Taft. Taft visited Albuquerque in 1909 promising statehood, and by 1911, it was clear he meant it. This photograph shows a parade down Central Avenue held in anticipation of the long-hoped-for event. (Courtesy Nancy Tucker.)

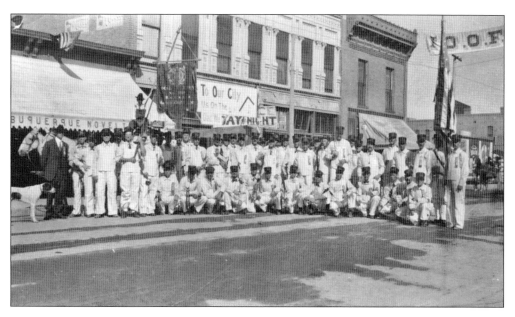

Because of the excitement surrounding New Mexico's imminent statehood, officials renamed the 1911 Territorial Fair the "30th Annual New Mexico Carnival and First State Fair." The parade that year was apparently spectacular, with every organization in town, including the local union (pictured above), taking part. The fair itself was an unsurprisingly huge event, featuring New Mexico's first airplane flight in addition to the requisite agricultural competitions, sideshows, dances, and other activities. The photograph below, although from an earlier fair, shows a year-after-year mainstay: the Albuquerque Indian School. In many ways, the state fair has always been a celebration of the many cultures in New Mexico. (Above courtesy Nancy Tucker; below courtesy CSR PICT 000-119-0734.)

As shown in this photograph of the event, on January 5, 1912, President Taft finally signed the proclamation admitting New Mexico as the 47th state of the United States of America. New Mexico's neighbor to the west, Arizona, would be admitted in six short weeks, thus completing the contiguous United States as they are known today. In Albuquerque, the occasion was marked by the town-wide sounding of bells and steam whistles. (Courtesy CSR Stinson Collection 000-506-2232.)

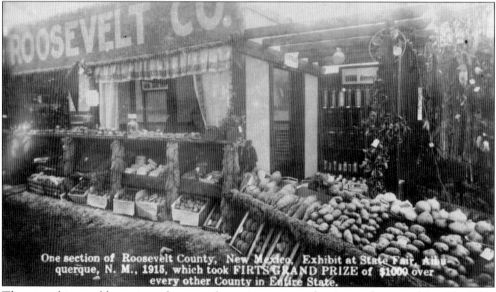

One section of Roosevelt County, New Mexico, Exhibit at State Fair, Albuquerque, N. M., 1915, which took FIRTS GRAND PRIZE of $1000 over every other County in Entire State.

The state fair would continue for several more years, now having truly earned its title. This photograph shows a winning agricultural exhibit from Roosevelt County, one of many such competitors from all over the state. Unfortunately, the 1915 event proved to be one of the last state fairs. After 1916, political maneuvering and a lack of profitability caused the fair to close and stay shuttered for two decades. (Courtesy Nancy Tucker.)

Harwood Industrial School
ALBUQUERQUE, NEW MEXICO

As Albuquerque became more populated and commercial in nature, schools became increasingly necessary. These early-1900s postcards show the Harwood Girls' School, opened in 1887 by Emily Harwood, the wife of a Methodist minister. The Harwood school boarded girls in the above downtown home and taught various subjects, including home making and cooking (as seen at right). Harwood was apparently an early promoter of bilingual education, as many of her students spoke Spanish as their first language. The school would survive for many decades and in several locations until it closed in 1976. (Both courtesy Nancy Tucker.)

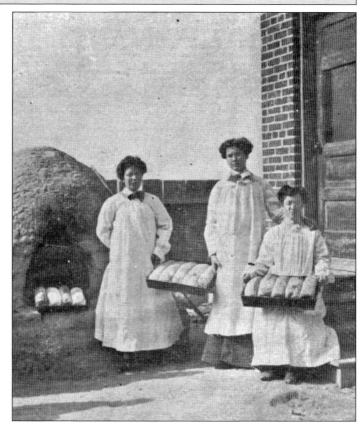

Boarding schools for Native American children had become a prominent, and unfortunate, part of U.S. policy by the second half of the 19th century. Native children, such as the girls shown below around 1900, were forced to attend schools far from their homes and forbidden to speak their native languages or engage in cultural practices. Albuquerque was home to the Indian Training School, the largest such institution in the state. Its campus, pictured above in about 1905, was built at the corner of Twelfth Street and Menaul Boulevard in 1882 and continued operations until 1980. The site of the school was then deeded to a federation of New Mexico's 19 Pueblos and developed into the Indian Pueblo Cultural Center. (Both courtesy Nancy Tucker.)

Originally, the U.S. government had contracted with the Presbyterian Church to run the Indian Training School in Albuquerque. The church did so from 1881 to 1882, when the government's school was built and the Bureau of Indian Affairs took over administration. However, the church had already purchased land in Albuquerque's North Valley for the purposes of building their own new facility, which in 1896 became the Menaul School (pictured in these early-20th-century postcards). The Menaul School's original purpose was the education of Spanish-speaking boys from New Mexico and Colorado. Though its mission has changed many times since its opening, the school still operates at its original site on Broadway and Menaul Boulevard. (Both courtesy Nancy Tucker.)

New High School Building. ALBUQUERQUE, N. M.

In 1891, a city bond approved the construction of public elementary schools in New Town Albuquerque, and thus was public education born in the developing city. The above c. 1920 postcard shows the Albuquerque High School, constructed at the corner of Central Avenue and Broadway in 1914, at that time far out on the edge of town. The building was designed to hold up to 500 students, then a seemingly huge student body. With the addition of other buildings throughout the years, Albuquerque High remained the city's only high school until 1949, when Highland High was built. The photograph below shows Albuquerque High's basketball team around 1920. (Both courtesy Nancy Tucker.)

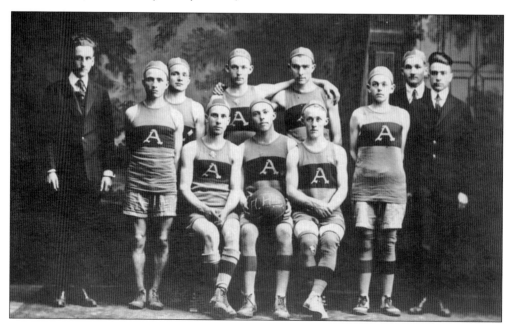

Public Library Gift to City of Joshua Raynolds.
Note the Sanitary Drinking Fountain near the Corner.

The above pictured building is Perkins Hall, which was constructed to serve the Albuquerque Academy, a private school that was, despite the name, based out of Colorado Springs, Colorado. By 1901, the academy had moved on, and the owner of Perkins Hall, one Joshua Raynolds, donated the building to become Albuquerque's first public library. In 1925, after the facility had suffered several small fires, the building was torn down and was replaced by a library designed in the Pueblo Revival architectural style (pictured below). This building served as the main library branch until 1978, when the main library moved downtown. (Above courtesy author's collection; below courtesy Nancy Tucker.)

The Albuquerque Public Library. 1925.
Compliments of the ALBUQUERQUE TRADES COUNCIL

CARPENTERS LOCAL UNION NO. 1319	PAINTERS LOCAL UNION NO. 823
PLASTERERS LOCAL UNION NO. 254	LATHERS LOCAL UNION NO. 238
ELECTRICIANS LOCAL UNION NO. 611	GLAZIERS LOCAL UNION NO. 1159
PLUMBERS LOCAL UNION NO. 412	LABORERS LOCAL UNION NO. 16

The Old Main Library, considered an excellent example of Pueblo Revival, was designed by architect Arthur Rossiter, and its interior was appointed by noted Santa Fe artist (and puppeteer) Gustav Baumann. After the main branch library moved downtown, the old library was given over to housing the library system's special collections and genealogical materials. This late-1920s postcard depicts the building's interior looking much the same as it does today. (Courtesy Nancy Tucker.)

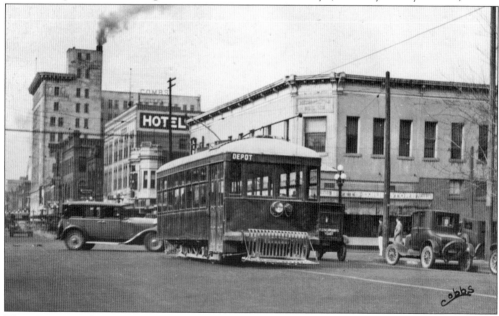

This 1927 view of Central Avenue from First Street shows the city as once again having reinvented itself. Gone were the horse-drawn streetcars, replaced now by electric trolleys and the ever-present automobile. Long gone was Hell's Half Acre, with prostitution having been deemed illegal in the early 1900s, and gone were the rough-and-tumble frontier days. (Courtesy CSR William A. Keleher Collection 000-742-0541.)

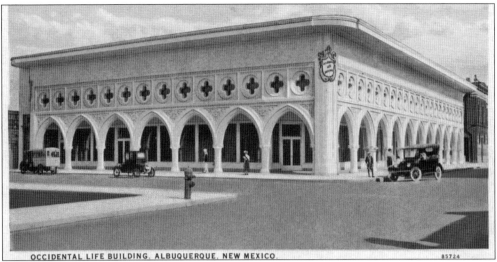

OCCIDENTAL LIFE BUILDING, ALBUQUERQUE, NEW MEXICO. 85724

The Occidental Life Building, completed in 1917, is one of Albuquerque's most recognizable buildings. This postcard is evidently pre-1933 because the flat roof was replaced by ornate crenulations after a fire destroyed both the building's roof and interior in that year. The original building was designed by Henry C. Troth to recall the Doge's Palace in Venice, and it was later remodeled by Miles Britelle. (Courtesy Nancy Tucker.)

The automobile was already changing the face of Albuquerque yet again when this 1930s photograph of Central Avenue was taken. Cars allowed Albuquerque to develop more residential neighborhoods farther away from downtown, and many citizens moved their families. As a result, downtown became more and more of a shopping and business district, with customers and employees commuting to the area by car instead of walking. (Courtesy Albuquerque Museum, Brooks Studio PA 1978-152-236.)

Fremont's Foods, pictured here in the 1950s, had been a mainstay on Central Avenue for many decades. Founded in 1918 at Central Avenue and Sixth Street by a Chinese immigrant named Edward Gaw, the store specialized in a wide variety of imported foods. Although the shop has changed locations many times, it is still owned by Gaw's descendants and is still in operation at its new location in northeast Albuquerque. (Courtesy Aimee Tang.)

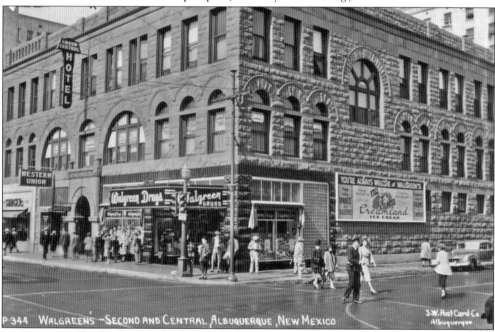

Downtown in the 1930s was a bustling place. Hotels, drugstores, restaurants, and taverns were springing up on every block. This c. 1930 photograph shows the busy intersection of Central and Second Avenues. National drugstore chain Walgreen's is in the foreground, and the Grand Central Hotel, one of a growing number in downtown, is just to the left. (Courtesy Nancy Tucker.)

Conrad Hilton was born in Socorro County, New Mexico, and built an inn and general store there. Later, of course, Hilton built up a considerable fortune through a hotel chain he began in Texas. He never forgot his New Mexico roots, however, and built his fourth hotel in downtown Albuquerque in 1939 (right). It was, by some accounts, the first modern high-rise hotel in the state. The building still stands and is set to reopen as the Hotel Andalaz in 2009. (Courtesy Nancy Tucker.)

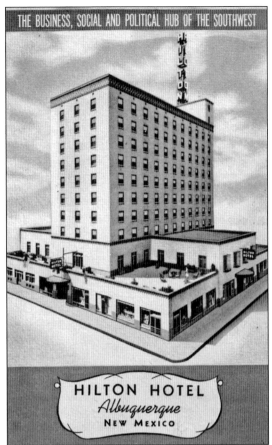

THE BUSINESS, SOCIAL AND POLITICAL HUB OF THE SOUTHWEST

HILTON HOTEL
Albuquerque
NEW MEXICO

One of the most architecturally arresting buildings in downtown Albuquerque was the Hotel Franciscan, built in 1923 and shown in this real-photo postcard during its construction. The building was funded by public tax dollars through the chamber of commerce (which had replaced the Commercial Club) and cost some $350,000. The sender of this postcard described it as "very beautiful against the blue sky in the sunshine." (Courtesy Nancy Tucker.)

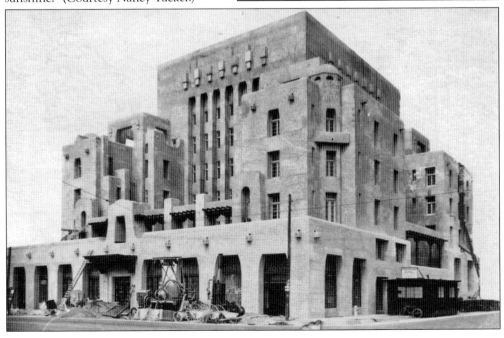

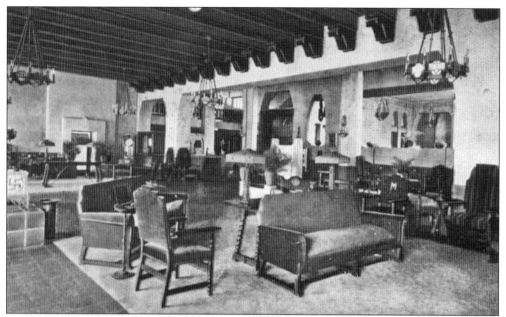

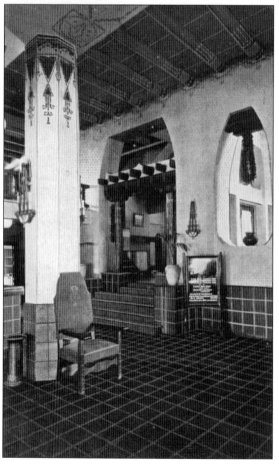

These 1920s postcards give some idea as to the grandeur and beauty of the Hotel Franciscan's interiors. The Franciscan was built to capitalize on the tourism and health-seeker boom of the early 1920s. Unfortunately, within the decade, both booms would be over because of the onset of the Great Depression. Americans were suddenly faced with serious financial hardships, and travel and tourism were luxuries they could not afford. Although the Depression did not hit Albuquerque as hard as it did many cities, the hotel industry was seriously affected. The Franciscan struggled on through the next half century but never attained the luxury landmark status of its peer, the Alvarado. It did, however, share its fate. In 1971, the Franciscan was demolished to make room for a parking lot. (Both courtesy Nancy Tucker.)

PRESIDENT TITE'S HOME OPPOSITE CAMPUS

STUDENT'S ROOM, UNIVERSITY OF NEW MEXICO

As noted in a previous chapter, the University of New Mexico flirted with the Pueblo Revival architectural movement under UNM president William Tight's administration. Unfortunately for Tight, the buildings he authorized utilizing the designs, including his own Central Avenue home pictured in the *c.* 1908 postcard above, proved controversial, and he was removed from office. However, by the 1930s, the university was again experimenting with the architectural style. (Courtesy Nancy Tucker.)

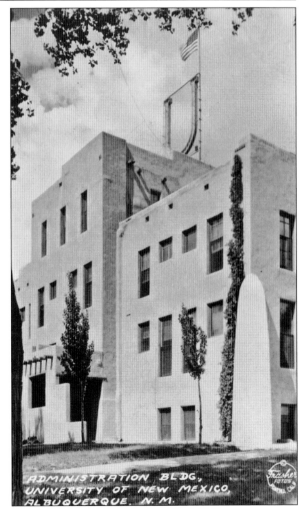

One of the odder additions to the campus was a huge, neon "U" attached to the top of Hodgin Hall by order of UNM president David Hill sometime in the early 1920s. Apparently, Hill wanted to make sure the university could be spotted from miles away, even at night. It is unclear when the "U" was taken down. (Courtesy Nancy Tucker.)

In 1933, the University of New Mexico made a fateful decision to hire architect John Gaw Meem to design Scholes Hall in the Pueblo Revival architectural style. Meem was famous for having refined (some say perfected) Pueblo Revival in Santa Fe's Sun Mount Sanatorium, a remodel of the La Fonda Hotel, and other projects. His work on Scholes Hall was popular, and he was soon commissioned to design other university buildings. The UNM Alumni Chapel (pictured above around 1940), Mitchell Hall, the President's House, and Zimmerman Library (shown below in a 1930s postcard) were all Meem designs, and his beautiful work would influence the overall design style of the university campus to the present day. (Both courtesy Nancy Tucker.)

Library
University of New Mexico
Albuquerque, N. M.

6.
PHOTO - REDMAN

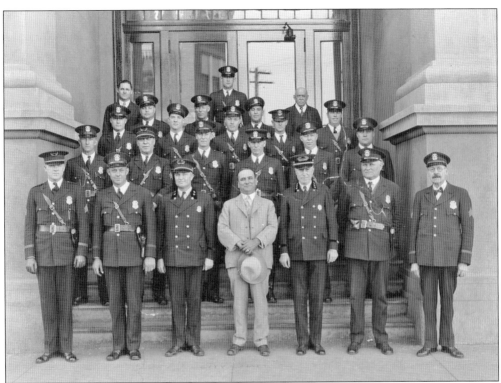

Anyone who spends any time in Albuquerque today will inevitably run across the name "Tingley." There is Tingley Coliseum, Tingley Beach, Tingley Drive, Tingley Hospital, and so on. The many Albuquerque "Tingleys" are a testament to the outsized impact and personality of "Mayor" Clyde Tingley, a city alderman, chairman of the Albuquerque City Commission, and later governor of New Mexico. During his political career, lasting from 1916 to 1955, Tingley was a fierce proponent of social welfare programs, city (and later state) beautification, and, during the Franklin Roosevelt presidency (which coincided with Tingley's governorship), the precepts of the New Deal. The above photograph shows Tingley as city commissioner (roughly equivalent to mayor) posing with members of the Albuquerque Police Department in 1932. At right is a photograph of Tingley's inauguration as state governor in 1934. (Above courtesy CSR, NM Pamphlet Collection MSS 112BC; below courtesy CSR William A. Keleher Collection 000-742-0255.)

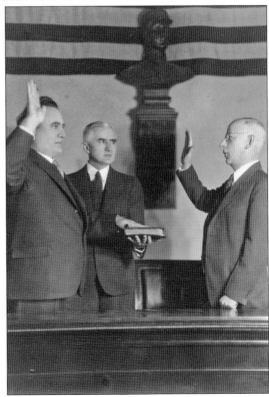

In 1910, Clyde Tingley followed his future wife, Carrie Wooster, to New Mexico from Ohio. Wooster was a tuberculosis patient, and after the couple married in 1912, they lived together in a TB cottage just west of the university area. During Clyde's political career, Carrie Tingley became a tireless crusader for children's welfare and secured funds for the construction of a hospital for crippled children. This photograph shows Carrie Tingley as of 1940. (Courtesy CSR William A. Keleher Collection 000-742-0332.)

City beautification was a major concern for Clyde Tingley during his time as Albuquerque city commissioner. In addition to streamlining the city's garbage collection and sewer management divisions, he also sought to improve the condition of Albuquerque's streets. Tingley is pictured here around 1930, posing with a group of state-of-the-art street cleaners. (Courtesy CSR Pamphlet Collection MSS 112 BC item #59.)

In 1930, Tingley ordered a city dump near the Rio Grande transformed into a lake to provide a swimming area for Albuquerque residents. Originally called Conservancy Beach, it was later renamed Tingley Beach in honor of its creator. Although the "Beach" (shown here in about 1940) has not been open for swimming since 1950, the park was thoroughly renovated in 2005, and today it serves as a fishing spot for Albuquerque families. (Courtesy Nancy Tucker.)

As city commissioner, Tingley believed aviation was necessary to the city's future. In 1928, he tried to secure city funds for Frank Speakman in order to develop a tract of land on the barren mesa into an airport. Unfortunately, the funds were not available, so Tingley loaned city construction equipment to Speakmen on weekends and after hours. This photograph shows Tingley at the completed airport in 1933. (Courtesy CSR Pamphlet Collection MSS 112 BC item #59.)

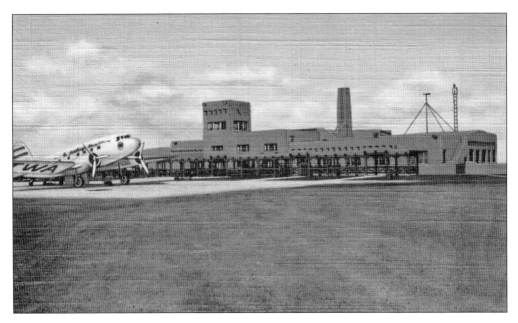

Although Speakman's airfield served the city through the early 1930s, by 1935, it was clear that a new, city-owned airport was needed. Tingley, governor at the time, secured federal funds to build the Albuquerque Municipal Airport at a new site in the city's highlands. The airport's main terminal, pictured above soon after its 1939 opening, was a Pueblo Revival–style masterpiece designed by city architect Ernest Blumenthal. The terminal cost $700,000, was built by Works Progress Administration workers, and used local materials, including adobe bricks and flagstone in its construction. Its interior was particularly beautiful, featuring massive wooden *vigas* in the lobby's high ceiling and comfortable recessed nooks such as the one shown in the 1940s postcard below. Although the airport has since expanded many times, the old terminal still survives just west of today's Sunport. (Both courtesy Nancy Tucker.)

Nine

THE MOTHER ROAD

This book ends with a road. Or, perhaps, it should be termed *The* Road, for what other mere highway has so completely captured the American imagination as U.S. Route 66? Even today, a half-century after its heyday, few can encounter that magical name without thoughts of resplendent neon, the erotic curves of a classic automobile, and the echo of long-ago songs:

> If you ever plan to motor west
> Travel my way, the highway that's the best.
> Get your kicks on Route 66!

So sang Bobby Troupe, Nat King Cole, Chuck Berry, and even the Rolling Stones. From 1927 to its decommissioning in 1985, U.S. Route 66 was so much more than a road; it was a 2,500-mile monument to a new American way of life, and at its heart was the growing cult of the automobile. With cars suddenly affordable and plenty of cheap gasoline, Americans had the ability to travel their country like never before.

> It winds from Chicago to L.A.,
> More than two thousand miles all the way.

And near its center lay Albuquerque.

MADONNA.

ALBUQUERQUE N.M.

Of course, U.S. Route 66 was not the first romantic westward route. The bygone days of wagon freighting and cattle drives carried names with their own mystique. The Santa Fe Trail, the Spanish Trail, and others were just as resonant in their time, and in 1912, the Daughters of the American Revolution (DAR) decided to promote a highway that would follow and memorialize these routes from coast to coast. Although the DAR never completed the dream of a National Old Roads Trail, they did produce 12 Algonite stone statues, known as the *Madonna of the Trail*, to mark the route. One statue found its way to Albuquerque in 1928 after being rejected by Santa Fe. Although the statue's original home, McClellan Park (pictured here), has since been replaced by a courthouse, the *Madonna* still stands at Fourth Street and Marble Avenue NW. (Courtesy Nancy Tucker.)

U.S. Route 66 was officially commissioned in 1926, and its original New Mexico route went west through Santa Fe before sweeping south toward Albuquerque. These real-photo postcards show two of the sights awaiting travelers of the time who followed the Mother Road from Santa Fe to Albuquerque. Above are the dreaded switchbacks of La Bajada Hill, an escarpment dividing New Mexico's historic Rio Arriba and Rio Abajo territories. Supposedly, the switchbacks were so steep that ascending motorists had to drive their vehicles backward to accommodate their gravity-feed tanks. The photograph at right shows "the Big Cut," a deep notch carved through the top of a forbidding ridge, considered a feat of engineering in its time. The La Bajada sections of U.S. Route 66 are still extant, and the Big Cut is visible from southbound I-25. (Both courtesy Nancy Tucker.)

In 1937, U.S. Route 66 was realigned to bypass Santa Fe altogether. Westbound travelers now entered Albuquerque through Tijeras Canyon and were greeted by Elephant Rock, pictured above around 1940. Elephant Rock marked the traveler's entry into the Rio Grande Valley and was often painted with advertisements for Albuquerque hotels and businesses. Although the rock was bulldozed off of its base in the 1970s, an observant traveler can still find it lying abandoned in a gully just east of the Town and Country Feed Store. On the other side of Albuquerque, U.S. Route 66 passed by another stone sentinel, Owl Rock, near Laguna Pueblo, pictured below in a 1940s postcard. (Both courtesy Nancy Tucker.)

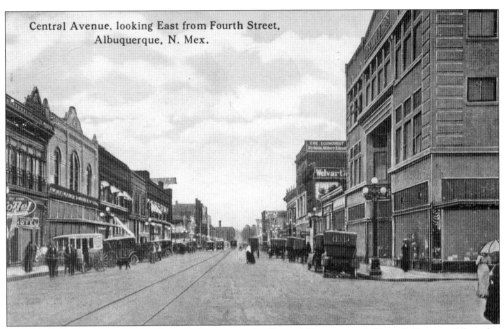

The original U.S. Route 66 alignment ran south along Albuquerque's Fourth Street. After the 1937 realignment, the road traversed Central Avenue across the length of the city. As a result, the intersection of Fourth Street and Central, shown here in a 1920s postcard, is one of the few places where historic U.S. Route 66 crosses itself. (Courtesy Nancy Tucker.)

As increasing numbers of motorists passed through Albuquerque on U.S. Route 66, downtown Central Avenue became something of an architectural showcase for the city. In 1927, the striking Pueblo Deco–style KiMo Theater, seen here in a 1950s postcard, joined landmarks like the Hotel Franciscan and the Alvarado in defining Albuquerque's unique downtown character. Unlike those long-gone treasures, however, the KiMo managed to survive to the present day. (Courtesy Nancy Tucker.)

HOEFGEN & BRANSON
1729 W. Central Avenue
Albuquerque, N. M.

To serve the growing multitude of motorists, gas stations sprang up along U.S. Route 66 like never before. This 1930s postcard of the Hoefgen and Branson station shows a classic example of streamline moderne architecture. The style is closely associated with U.S. Route 66's golden age. Several buildings in the style still exist along Central Avenue, including Kelly's Brew Pub in Nob Hill and the Standard Diner in the Huning Highlands. (Courtesy Nancy Tucker.)

A-51—NOB HILL BUSINESS CENTER, 3500 EAST CENTRAL AVE., ALBUQUERQUE, N. M.
NEWEST, MOST MODERN AND CONVENIENT SHOPPING CENTER

The Nob Hill Shopping Center (shown in this 1940s postcard) also employed the streamline moderne style to great effect. Automobiles allowed Albuquerque residents to commute farther between their homes and places of employment, and as a result, Albuquerque's eastern Highlands were developing quickly. The Nob Hill Shopping Center was built with commuter culture in mind and was one of the first Albuquerque businesses to incorporate a parking lot into its design. (Courtesy Nancy Tucker.)

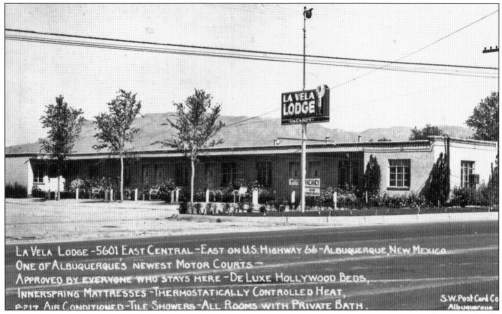

LA VELA LODGE -5601 EAST CENTRAL -EAST ON U.S. HIGHWAY 66 -ALBUQUERQUE, NEW MEXICO
ONE OF ALBUQUERQUE'S NEWEST MOTOR COURTS -
APPROVED BY EVERYONE WHO STAYS HERE - DE LUXE HOLLYWOOD BEDS.
INNERSPRING MATTRESSES -THERMOSTATICALLY CONTROLLED HEAT.
P-217 AIR CONDITIONED -TILE SHOWERS -ALL ROOMS WITH PRIVATE BATH.
S.W. Post Card Co
Albuquerque

As with rail travel, with increasing numbers of tourists came an increasing need for roadside accommodation. The number of tourist camps (the precursor to the motel) along Albuquerque's Central Avenue climbed from 3 in 1935 to 98 in 1955. Centralization, endemic to hotels designed to meet the need of rail travelers, was simply not a factor for the motorist, and as a result, motels were sprawled across the length of Albuquerque's portion of U.S. Route 66. With increased competition among the motels came an increase in both amenities and advertising. Businesses such as the La Vela Lodge employed postcards, like this early-1940s example above, to spread the word about the luxurious accommodations they offered. Others, like the Tewa Lodge in this 1960s postcard below, capitalized on Southwestern design motifs for roadside appeal. (Both courtesy Nancy Tucker.)

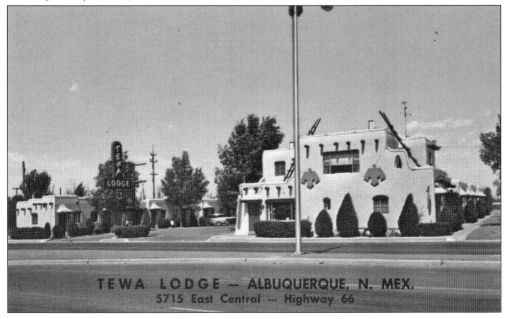

TEWA LODGE — ALBUQUERQUE, N. MEX.
5715 East Central — Highway 66

This 1940s advertisement for the Spanish Gardens Motel gives a glimpse of the accommodations that awaited the typical motorist on prewar U.S. Route 66. The bedroom, in particular, is surprisingly small by today's standards, but the kitchenette was no doubt a necessity for the budget-minded traveler. Also of note is the use of "hollow tile walls" to keep the unit cool during summer nights before air-conditioning was widely available. With the advent of the interstate system, Central Avenue was no longer a visitor's primary route through Albuquerque, and many of the old motels fell into disrepair and became magnets for crime. Although examples remain, many more have been torn down under the city's nuisance laws. (Courtesy Nancy Tucker.)

Motorists, of course, brought their appetites with them, and Albuquerque's restaurant industry rapidly expanded to meet their needs. Diners had many options to choose from, and the Court Café proved to be one of the most popular. Located at the intersection of Central Avenue and Fourth Street, the café's art deco facade (pictured at right around 1940) beckoned tourists, and its advertising slogan reassured them they could "come as you are." Inside the eatery was decorated in a style somewhere between greasy spoon and Southwestern nouveau, with wall-mounted murals, such as the one reproduced below, providing glimpses of New Mexico sights and scenes from its history. (Both courtesy Nancy Tucker.)

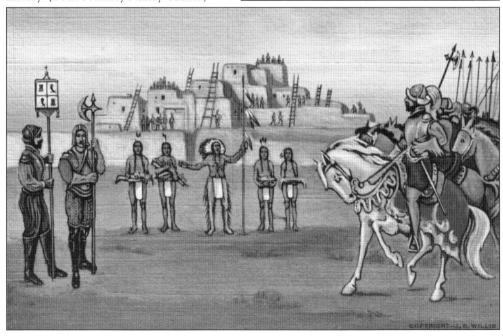

The Kiva Café was another popular spot for diners. Located in a corner of the spectacular KiMo Theater, the café proved an appealing spot for locals and travelers alike. Many Albuquerque businessmen made the Kiva a part of their morning ritual. This 1940s postcard shows a typically bustling meal at the café. (Courtesy Nancy Tucker.)

With Albuquerque's automobile-enabled eastward expansion came new opportunities for business. The New China Town Restaurant was one of Albuquerque's first Asian eateries, opened by one of the city's oldest Chinese families. The restaurant remained operational until the early 21st century and featured one of the area's few tiki bars. (Courtesy Nancy Tucker.)

As with Albuquerque's motels, increased competition among restaurants and gas stations led to dramatic attempts to draw the business of the motoring tourist. Mimetic architecture was one of the most outrageous ways to catch the passing traveler's eye. By giving their building an unusual shape, business owners hoped consumers would be curious enough to stop. Albuquerque boasted several examples of this peculiar trend, including the Sombrero Café (featured on the above 1960s postcard) and the Iceberg Service Station, shown below. Although both of these unusual buildings are long gone, a remnant of one of the Sombrero Café's locations can still be found attached to Quarter's Barbecue on South Yale Boulevard. (Both courtesy Nancy Tucker.)

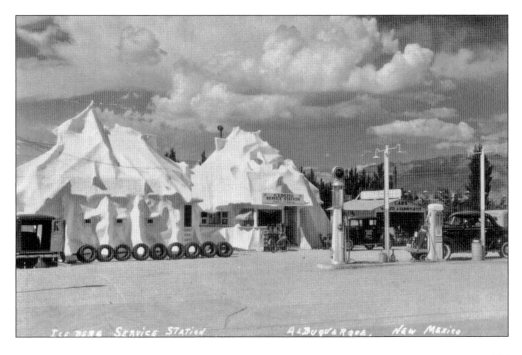

By the 1950s, Central Avenue had become a river of neon as businesses sought to outdo each other in attracting motorists. At left is the sign from Jack's Lounge and Liquor Store, which figures prominently in Rudolfo Anaya's book *Alburquerque*. Below is a 1950s photograph of downtown Albuquerque at night, a sight that must have made quite an impression on the visitor. It was this radiant highway that literally paved the way to Albuquerque's future. During its heyday, U.S. Route 66 and the car culture it represented would enable a series of population booms that would render the city nearly unrecognizable from its earlier identities. And yet, for those who have not forgotten them, those identities still remain. (Both courtesy Nancy Tucker.)

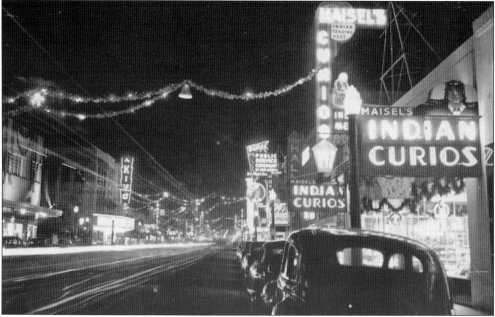

BIBLIOGRAPHY

Balcomb, Kenneth C. *A Boy's Albuquerque*. Albuquerque, NM: University of New Mexico Press, 1980.

Bryan, Howard. *Albuquerque Remembered*. Albuquerque, NM: University of New Mexico Press, 2006.

Fergusson, Erna. *Albuquerque*. Albuquerque, NM: Merle Armitage Editions, 1947.

Johnson, Byron A. *Old Town, Albuquerque, New Mexico: A Guide to its History and Architecture*. Albuquerque, NM: City of Albuquerque, 1980.

Oppenheimer, Alan J. *The Historical Background of Albuquerque, New Mexico*. Albuquerque, NM: Urban Development Institute of the University of Albuquerque, 1969.

Sanders, Jeffrey C. *McClellan Park: The Life and Death of an Urban Green Space*. Albuquerque, NM: The Albuquerque Museum, 2004.

Sargeant, Kathryn, and Mary David. *Shining River, Precious Land: An Oral History of Albuquerque's North Valley*. Albuquerque, NM: Albuquerque Museum, 1986.

Simmons, Marc. *Hispanic Albuquerque*. Albuquerque, NM: University of New Mexico Press, 2003.

———. *Spanish Pathways, Readings in the History of Hispanic New Mexico*. Albuquerque, NM: University of New Mexico Press, 2001.

Thomas, D. H. *The Southwest Indian Detours: The Story of the Fred Harvey/Santa Fe Railway Experiment in "Detourism."* Phoenix, AZ: Hunter Publishing Company, 1978.

Usner, Don J. *New Mexico, Route 66 on Tour*. Santa Fe, NM: Museum of New Mexico Press, 2001.

DISCOVER THOUSANDS OF LOCAL HISTORY BOOKS
FEATURING MILLIONS OF VINTAGE IMAGES

Arcadia Publishing, the leading local history publisher in the United States, is committed to making history accessible and meaningful through publishing books that celebrate and preserve the heritage of America's people and places.

Find more books like this at
www.arcadiapublishing.com

Search for your hometown history, your old stomping grounds, and even your favorite sports team.

Consistent with our mission to preserve history on a local level, this book was printed in South Carolina on American-made paper and manufactured entirely in the United States. Products carrying the accredited Forest Stewardship Council (FSC) label are printed on 100 percent FSC-certified paper.

MADE IN THE USA